BERYL COOK
HAPPY DAYS

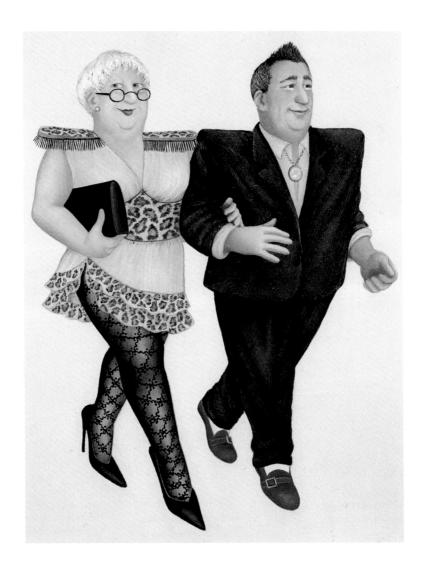

Victor Gollancz
London

other books of paintings by Beryl Cook

THE WORKS
PRIVATE VIEW
ONE MAN SHOW
BERYL COOK'S NEW YORK
BERYL COOK'S LONDON
BOUNCERS

First published in Great Britain 1995
by Victor Gollancz
An imprint of the Cassell Group
Wellington House, 125 Strand, London WC2R 0BB
© Beryl Cook 1995

A catalogue record for this book is available from the British Library.

ISBN 0 575 06192 8

Printed in Italy by Amilcare Pizzi s.p.a.

ART IS UNPREDICTABLE; it pops up like mushrooms in the most unlikely places. Who would have thought that one of Britain's best artists would emerge, untrained, from a boarding house in Plymouth? For Beryl's are such wonderful mushrooms!

Beryl Cook's first painting was done in reaction to her young son's efforts. With a box of paints she'd bought him for Christmas, he painted a picture with a sky at the top and a house and some grass at the bottom.

'But there's nothing in the middle,' she told him.

'There *is* nothing in the middle,' he replied.

'I'll show you how to paint something in the middle!' she said, and she painted a lady with large, pendulous breasts and eyes looking directly right. She was so surprised by what she'd done, she told me, that she felt as though she'd been punched in the stomach. She didn't paint again for a couple of years. Then there was no stopping her.

'Why do you go on?' I asked her.

'Because,' she said, 'I'm always disappointed by the result. The picture's always so bright in my mind and I have such high hopes for it before I start, but when I've done it I can't look at it for a while. Then I see something else – have another idea – and so it goes on.' She admitted that when she looks back at her work she's surprised and not displeased by what she's done, but it's always her hope for the next that drives her on.

There are two quite different ways of seeing. You can let your eyes relax and your gaze expand so that you don't look at anything in particular but take in the whole view: Turner and the Impressionists saw like this. This is a polite way of looking. Or you can stare hard at something, making it appear real and solid, as Beryl does. This is a rude way of looking. Children are quickly taught that it's wrong to stare, but many artists remain children all their lives and don't stop staring. L.S. Lowry stared not only at people but at animals too. One of his friends had a dog that used to take on Lowry's gaze. They would stare at each other until either the dog barked or Lowry laughed. The animals and the people in Lowry's pictures, like those in Beryl Cook's, are always looking at something.

Donald McGill, the superb artist of saucy postcards, didn't just stare but *pointed* at all the funny people on the beach. He got away with it in the strict Edwardian age, because the seaside then came under the sway of the Lords and Ladies of Misrule. Their rude jokes were allowed in the music halls at the end of the pier. Beryl Cook emerged naturally from this rich seam of British visual humour. She discovered it within her as she observed it around her, with increasing warmth, love and laughter. And so do we.

Who else could have imagined such an incongruous and wondrous owner in 'Rusty Car'? Who could have balanced the Orange Maid lolly in the young girl's mouth with the arum lilies that refused not to come up, in 'Garden Centre'? And who would have realized that the lorry's big hubs in 'Wheels' needed the companionship of the bicycle's delicate spokes, despite the obvious difference in size?

Beryl Cook doesn't stare – she's too polite – but just look at her looks: the two elderly ladies picking their way with disapproval through the rubble in Buenos Aires or the more youthful ladies eyeing the sailors dancing with different degrees of desire and availability.

Beryl Cook's heart goes into getting the expression right. When I visited her once, she was busy painting in the front room upstairs (her only studio), and didn't want to be disturbed. I'd drunk a few cups of tea and had had a long conversation with the cat before she allowed me in, but by then the face she was working on had been scrubbed out. She just couldn't get it exactly right. Beryl Cook paints thinly, on white boards so that the light background shows through the paint and makes each colour glow. Every detail therefore has to be painted right first time or she has to start again. Any corrections would reduce the picture's luminosity.

It's not just the faces, but the whole of Beryl's paintings that have a 'look'. She fills them up with bold, clear designs that immediately cheer you up. Her description of the tango bar is very telling. She was uncomfortable when the bar was empty, except for a frenzied couple dancing, but when many more customers arrived she was happier, stopped laughing nervously, and 'everything settled down'. Matisse thought that a painting should be like a comfortable armchair. Beryl Cook makes her pictures comfortable by filling them with people, like the crowd behind the happy couple in 'Sailors & Sweethearts', or with nice round things, like beer mugs or cabbages or buxom fairies. Her art celebrates people's companionableness and makes us all feel, with good reason, a lot happier.

If the art is to hide the art, Beryl Cook is a fine artist. Looking at her work, you are irresistibly drawn into its spirit and warmth. Each picture tells its story so effortlessly that it is easy to overlook how beautifully it's been drawn and observed. The variety of expressions of each member of the family in 'Going Swimming' and the comic detail of the ample lady floating in the rubber ring may lead one to overlook the magnificently drawn figure of the young mother, so confident of being up to the minute in fashion, from head to toe. What other artist of today has recorded so well the changing styles of ordinary life, or its crazes and rituals, such as the 'Hen Party'. Here you can see the artist at work, because, exceptionally, Beryl Cook has painted two images of the same scene. Superficially one appears to be a detail of the other, but when you study each more closely you can see she has changed every detail, every expression, even the colour and scale of the ribbons, and the candle on top of the box, to create a completely different or, rather, differently complete picture.

When you look closely at her compositions you can see that everything in them, every movement, mass, look and shape is balanced or echoed, one by another, until the whole picture seems to dance together. This is why, seeing two twins reflected in a mirror, she 'could hardly wait to start the painting'.

I invited Beryl up to Glasgow because I wanted her work to star in our new Gallery of Modern Art and I thought it would be great to get her to paint something local. She was a bit dubious at first because she wasn't sure she'd see anything – and she can't paint to order. But she needn't have worried. She saw things at once, in the street, in the karaoke room upstairs in the Horseshoe Bar. It was there that I saw how she saw. She is good company, hilarious often, but her eyes are always alert, watching. At times they seemed to dance round the room with delight. She opened her handbag and made a few pencil notes, casually, on a small pad. Or, occasionally, she or her husband John would take a flash photo with a little camera. Nobody minded – people are used to such things, and nobody noticed her attentiveness. Art begins with seeing. Something interested her in the confidence of the movement of these homely pop stars singing karaoke, which she has so beautifully captured in the painting.

'By the Clyde' began with the bright orange bus, with its emblazoned advert, going over a bridge against a grey sky. The rest of the picture grew around it – an amalgam of sights from various places. She'd seen the girl's outfit in Central Station, and on a boulder by the bridge she'd seen the graffiti 'wogs out'. John said she couldn't put that in because the city authorities wouldn't like it, but she felt the picture needed it and I said it was up to her as she was the artist. So she put it in, but faintly, as though the Cleansing Department had almost managed to scrub it out. So this painting, which looks as though it is from the life, is in fact a combination of memories that creates one living, memorable image. You can't ask an artist to do more than that – except, as we hope Beryl will, to carry on!

Julian Spalding
Director of Museums and Art Galleries, Glasgow

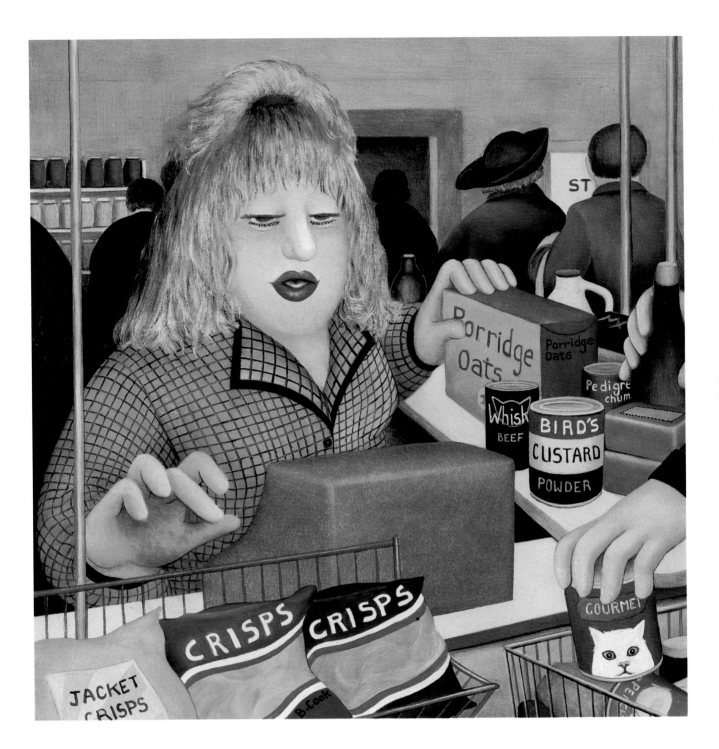

CHECKOUT GIRL

I grew fascinated by this girl at the checkout till in one of our supermarkets, and always waited in her queue. The mountain of hair first drew my attention and then I saw what a perfect mouth she had, painted a glistening scarlet. She was always very pleasant and great was my disappointment when she suddenly disappeared, for I had started a picture of her. The hair was the most difficult part of this painting and I strove long and hard to get a sufficient quantity of golden tresses to cascade from her head.

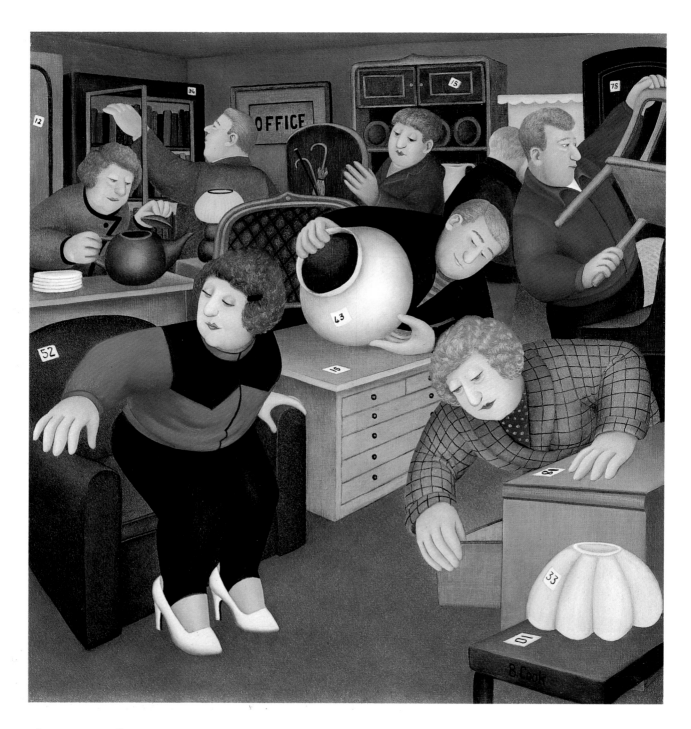

AUCTION ROOM

This is where a lot of the treasures in our house have
come from, here and the junk stalls. I have visited this
saleroom so many times, and find the seriousness with
which each item is examined so appealing, that I
decided to have a go at painting it. I don't go down to
bid, only to view. John does the bidding and he told
me once that one of our friends decided to play 'In
The Mood' on an old piano during the proceedings,
and received a sharp reproof from the auctioneer for his
trouble. I was sorry I'd missed this episode, I must say.
We now try to control our buying – there simply isn't
any more room here to pack it all in.

ELVIRA'S *opposite*

This is a picture of my son and daughter-in-law's café,
in which they serve sausage sandwiches (amongst other
things). It was the first time I had heard of these tasty
items and I questioned Teresa closely about how they
were assembled and how many sausages were used.
Here you see one about to be tackled by the lady in
front, with Teresa enjoying the view she had of one of
the many handsome marines who frequent the café, for
they are stationed in barracks just around the corner. In
the summer they sometimes arrive in sporting gear, like
this vest and tiny shorts. Dogs go in with their owners
as well and they often get little treats from the leftovers.

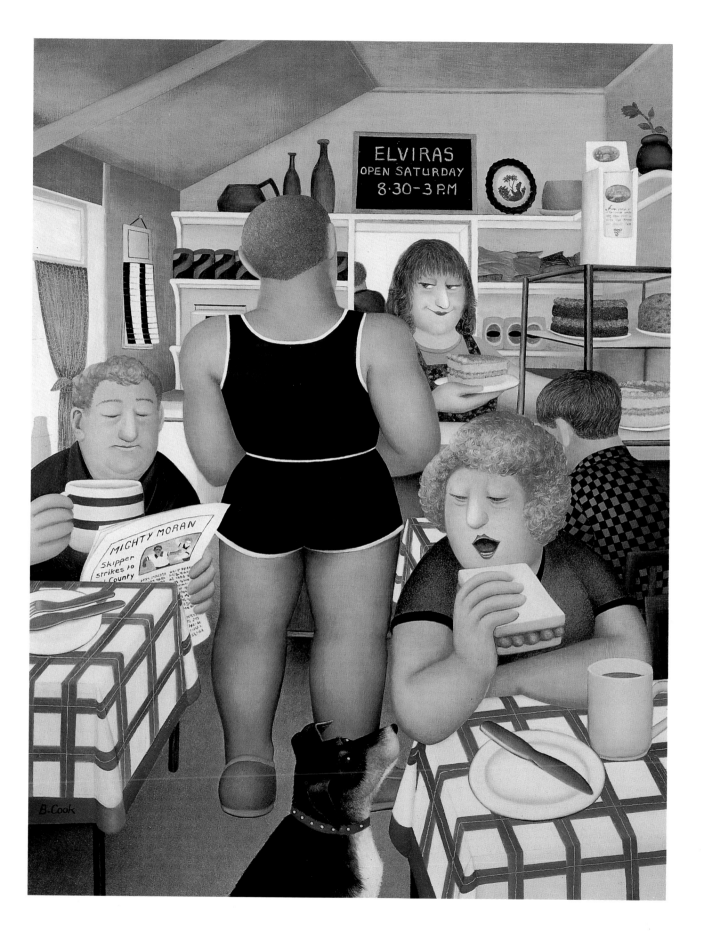

TELEPHONE

We still have one of the old red telephone boxes on the Hoe and I used it as a model for this painting. A friend regularly sends me these cards he collects from phone boxes in London and one day I found the best way to use them. Some are illustrated and others written out by hand. What full days (and nights) these girls must have – writing out and placing the messages, back home again to receive any calls and then possibly having to strap themselves into a restricting little black leather number ready for action. The lady on the phone is not ringing for any of these services, she's just chatting to a friend.

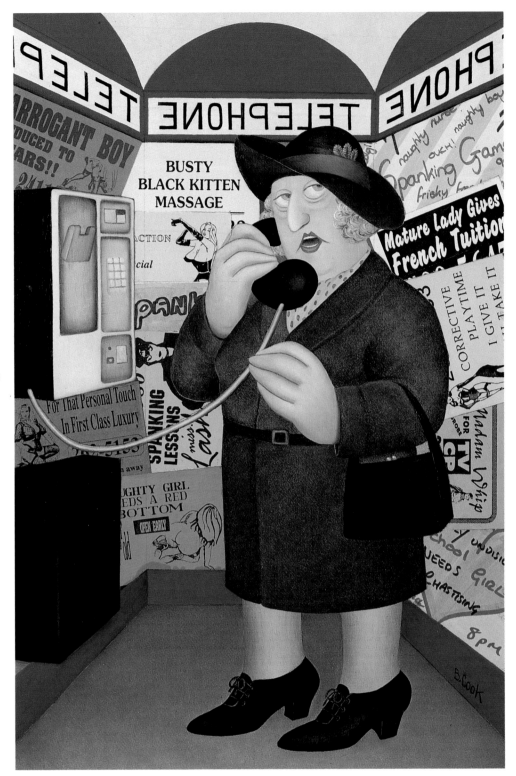

THE ESCALATOR *opposite*

I'm quite often requested to paint ladies in leggings. I've even been sent photographs of suitable models and this escalator seemed an ideal place to put some. I had taken a photograph of it in a local store and liked the striking design it made. Leggings are very popular down here, those of really exotic clashing colours being the most popular of all, though I'm sorry I was not able to depict them here. But I did have a chance to include the row of elegant legs used for displaying stockings, which rather pleased me. I have six of these myself, the remains of an accidental purchase of twelve from an auction. Friends carried off the others.

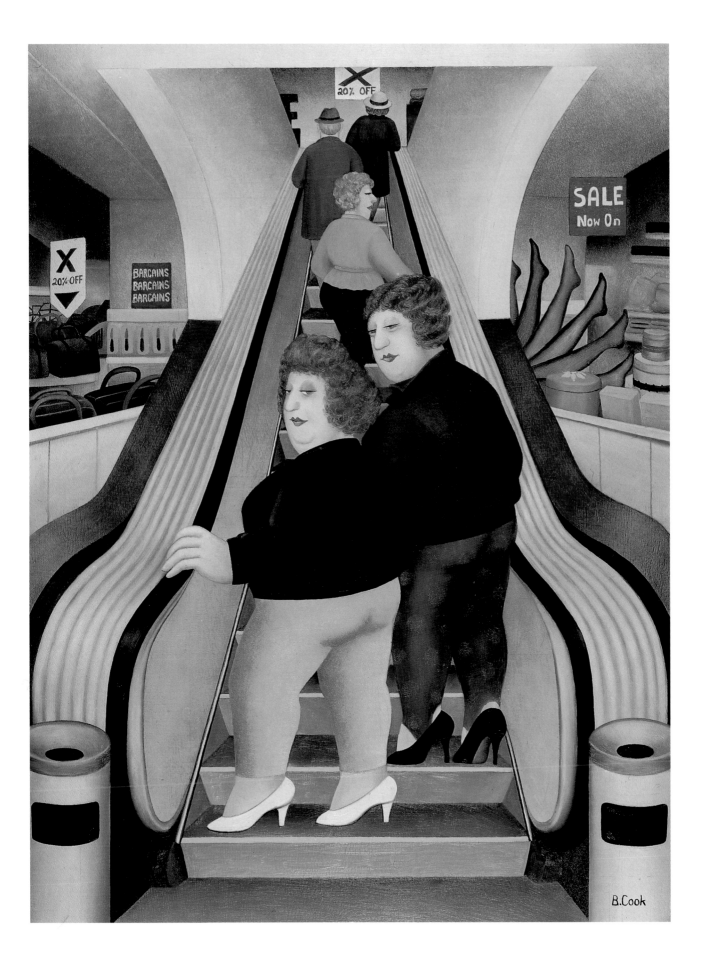

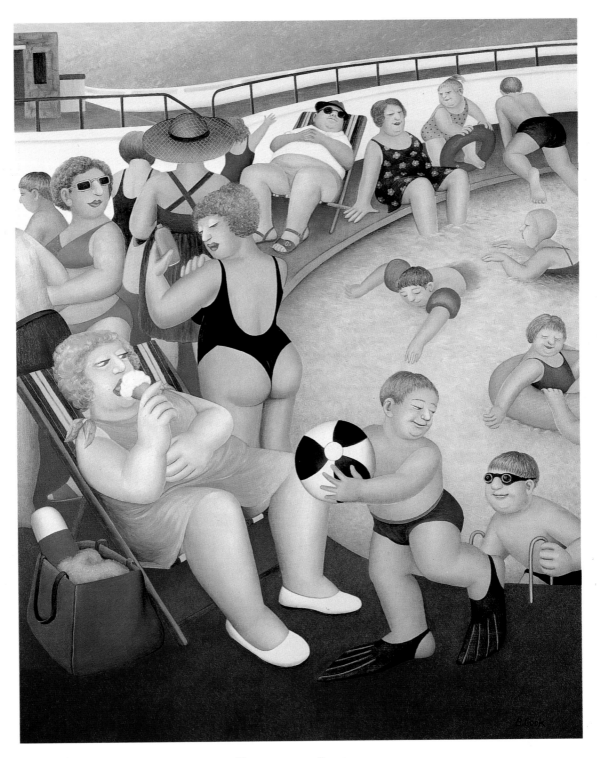

BATHING POOL

If only our outdoor pool was still humming with activity like this.
It is very nicely placed on the seafront and years ago it did a thriving trade, with
children playing in the fountains and deckchairs laid out all round for us onlookers. But a few bad
summers and a lot of foreign holidays have now closed it down. When it seemed likely that this would
happen I thought I would paint its happier times and include the girl wearing the cutaway
swimsuit I'd recently seen on a nearby beach. We still have little bathing pools set in amongst the
surrounding rocks and swimmers ready to plunge into the sea at the first sight of sunshine,
which is very brave of them for the water here is absolutely icy.

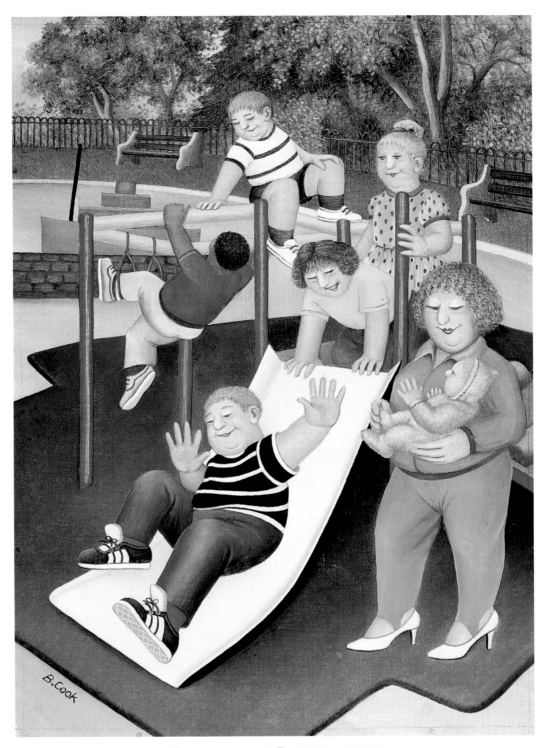

CHILDREN'S PLAYGROUND

The bathing pool may have closed down, but we still have some good playgrounds here in the parks and I pass one of them nearly every morning when we're out with the dog. I was asked for a painting for a children's charity: sometimes I paint fairies for these but this time I decided to do the playground with children playing. The trainers the little boy wears have large tongues emerging from the laces, all the rage when I painted the picture.

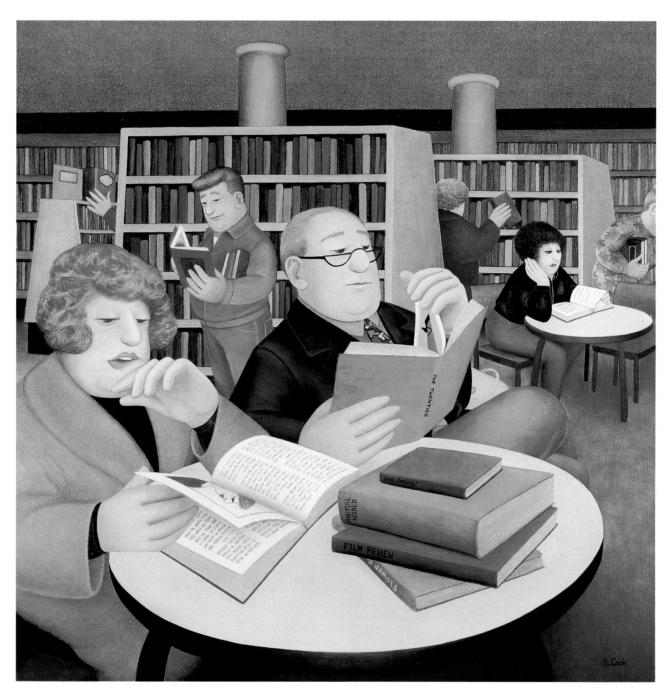

PUBLIC LIBRARY

I love reading, and have used this library for many years now. I can get books for pleasure, books to tell me about other countries when we are planning to travel, books to show me what a bassoon looks like if I should suddenly need to paint one, and even a book to teach me how to paint it if necessary! For this painting I took notes of the bookshelves and furniture each time I made a visit so I could try to make it authentic. To get the books right I copied a pile of my own, artistically arranged on a nearby table.

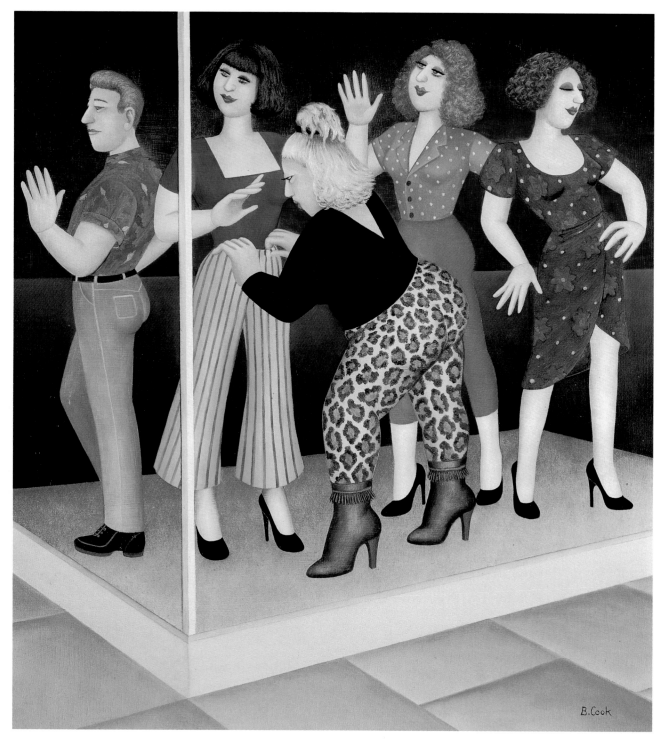

WINDOW–DRESSER

I am intrigued by the models I see in shop windows, perhaps because of the rather grotesque positions they are forced into in order to show off the clothes. My attention was first drawn to a little, well-rounded window-dresser who changed the outfits every morning. She was so different from the models she was clothing and extremely nattily dressed herself, often in clinging tights or micro skirt.

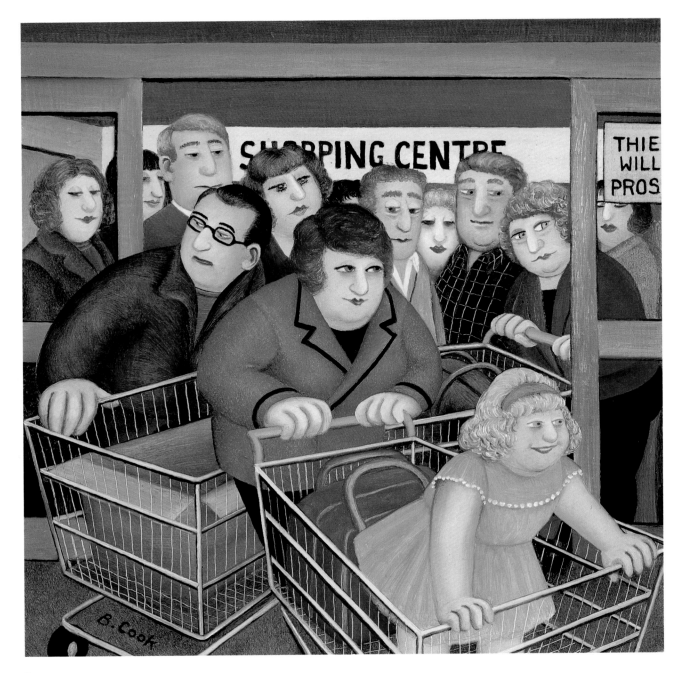

SHOPPING

We go shopping early in the mornings and sometimes have to wait for the supermarket to open. There is always a small crowd gathered, and a large crowd if it is the start of a bank holiday, for this is when shopping frenzy reaches its peak. We experienced shoppers really come into our own then, edging to the front by ruthless manipulation of the trolleys and rushing first through the doors when they are opened. I'm so fast I've already left this picture and am at the other end of the store with my trolley nearly full.

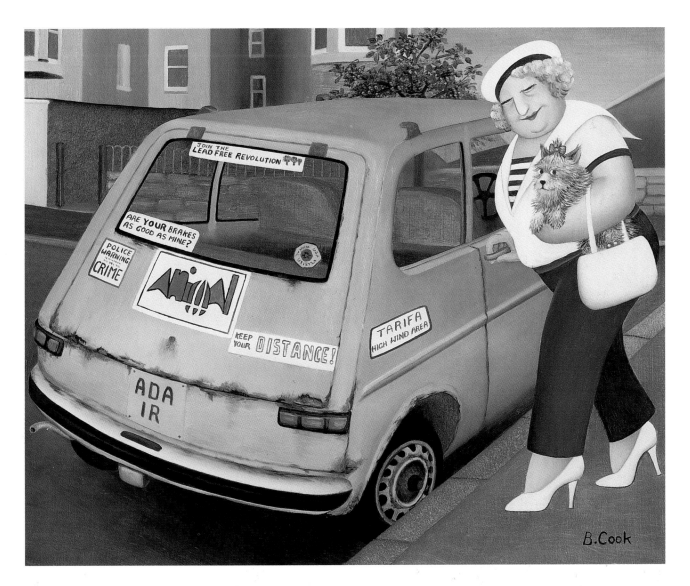

Rusty Car

For a long time this little car remained parked outside a house we passed each morning. I grew more and more interested as I read the messages and noticed the extensive rust, something I like painting very much. To finish the picture off I added the sort of person I thought might own a car like this, and then found a cherished registration number from one of the long lists they print in the Sunday papers.

RHUBARB

From rust on a car I promoted myself to a much larger expanse of corrosion, the corrugated iron shed in the allotments. Not that the rust alone attracted me, it was also the contented people I saw tending their plants each time I looked over the fence. And *what* fine plants they were growing – huge cabbages, lettuces, runner beans, well-protected soft fruit, even flowers. This was not an easy picture to compose. I was reluctant to leave any of the plants out but had to make room for a rusty shed and smoke-filled barrel, as well as make an attempt at perspective. All the cabbages were painted from a big one I bought in the market.

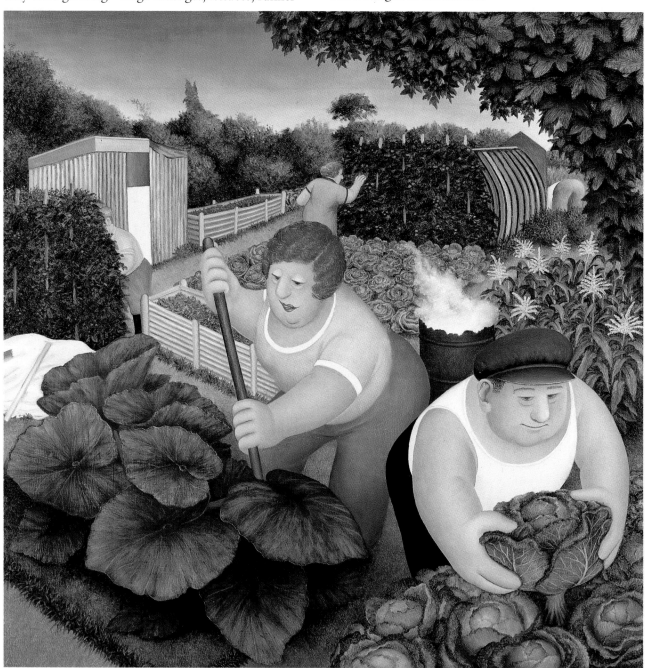

GARDEN CENTRE *opposite*

I used several of the plants in our garden for this painting. I have been cultivating a large privet chicken for years (which has now given birth to half a dozen small ones, grown from cuttings) and the lily regularly makes an appearance despite being cruelly cut back. There is something very soothing, and expensive, about a visit to the garden centre and it is a popular Sunday afternoon outing down our way. Halfway through all these plants I asked myself if it was really necessary to paint each leaf separately. The answer was yes – because so far I haven't been able to find a better way.

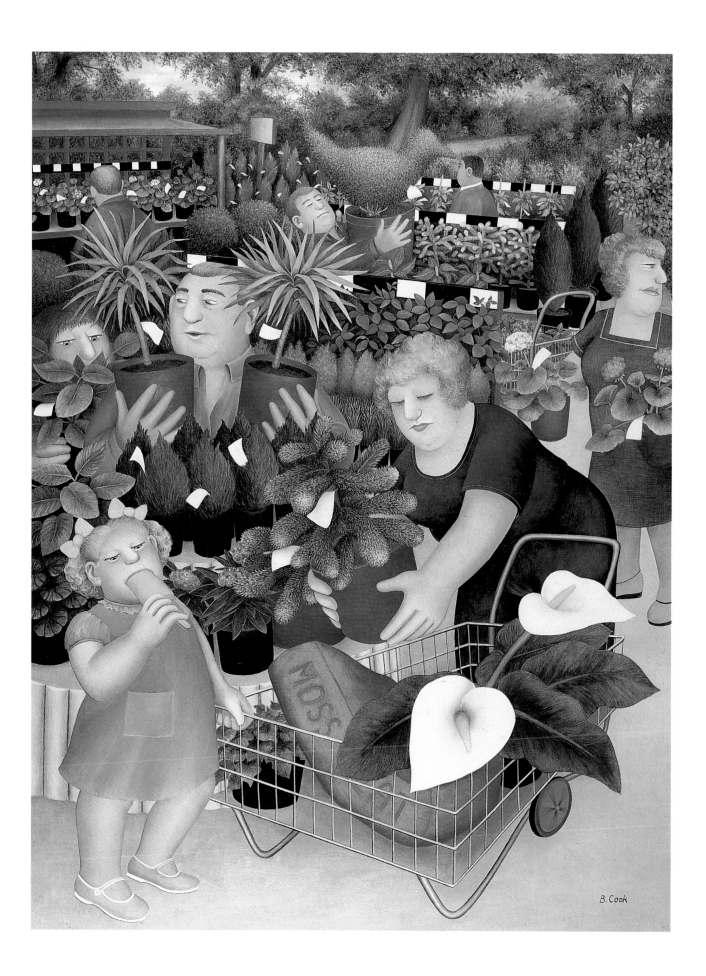

B. Cook

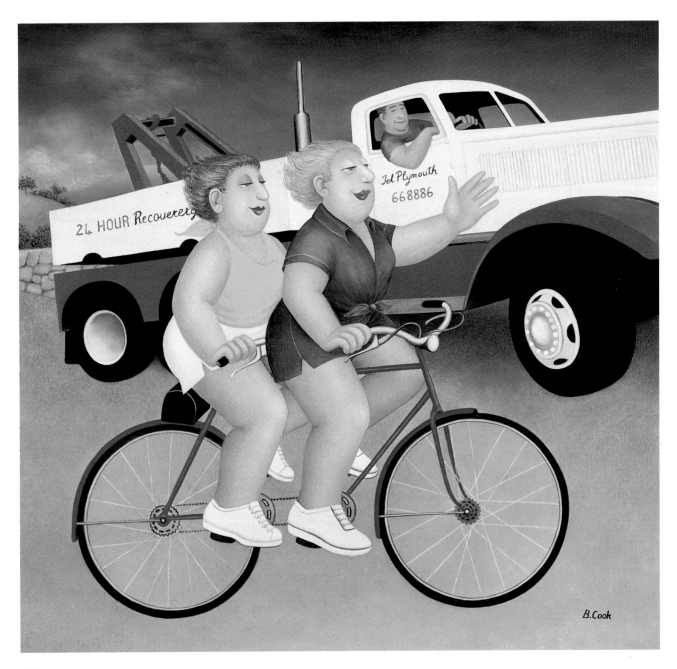

WHEELS

I had thought about painting a bicycle picture for some time but had been unable to work out the best way of doing it until I started to draw this lorry, and realized that a tandem would fit in here and make a tasteful arrangement of wheels. As I haven't got a tandem, or a picture of one, a stretched bicycle seemed to be the answer. I thought I'd succeeded with this until I showed it to a cyclist! I now learn that there are also such things as tandem tricycles, and I've every hope of capturing one of these in a painting one day. The lorry-driver here is not very good at spelling.

A Picnic

Rather a grand picnic, a feast fit for a king.
This isn't a king asleep beside it, however, but Sir
Clement Freud, having forty winks in the shade of a
tree. I listened to a talk he gave on the radio one after-
noon and he happened to mention how difficult it was
to buy Grape Nuts. I love these little morsels and I
heartily agreed with him – I had been forced to write
to the manufacturers complaining that I couldn't find
them. I'm glad to say that they are readily available
now, and I've painted him a nice big box of these to go
with all the other goodies laid out on the cloth.

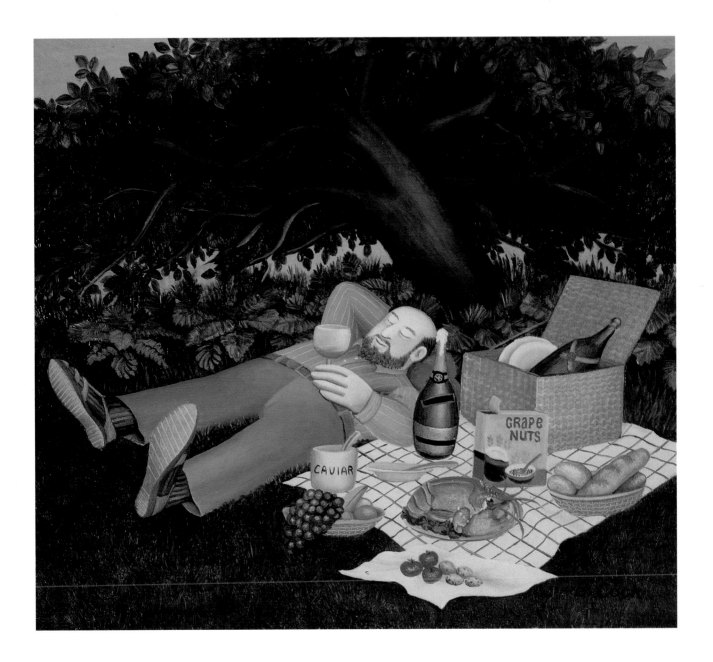

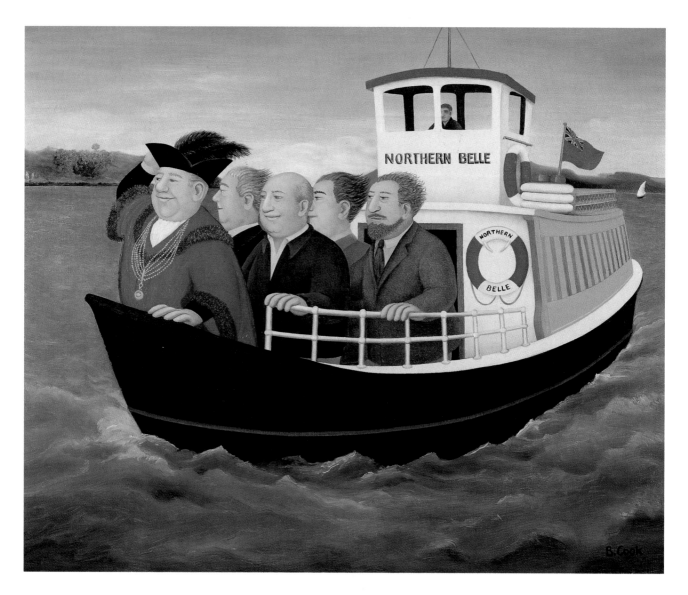

GOING TOWARDS ART

A few years ago we had an artistic celebration called the Four Cities Project, which was arranged for artists to set up various happenings around the city. Lights were strung in a pattern across Drake's Island, irregular spurts of water came from pipes in an old warehouse, and an attachment was made to an abandoned railway bridge. There was also an underground happening across the water at Mount Edgcumbe, and Bernard Samuels from the Arts Centre, who was explaining the scheme to me, said that the Mayor, himself and several others would be travelling across on the ferry. This was the most exciting happening of all to me, and in no time at all I had sought out a picture of the Mayor in his robes and taken a photo of the ferry. Bernard can be seen behind the Mayor, the others I made up – with carefully tousled hair, for it would have been a blustery crossing.

PICNIC AT MOUNT EDGCUMBE *opposite*

This is what the ferry party might have seen on their arrival. It is such a lovely park and playground, and so large that however many people go there it never seems crowded or uncomfortable. The dogs enjoy it just as much as the children, and benches and tables are there for picnics. This one has some hefty sandwiches, and pasties too as we are in Cornwall. I saw this young woman playing ball and liked the way she threw herself up in the air. I felt I had to add our little dog Minnie to the group, since this was her favourite game.

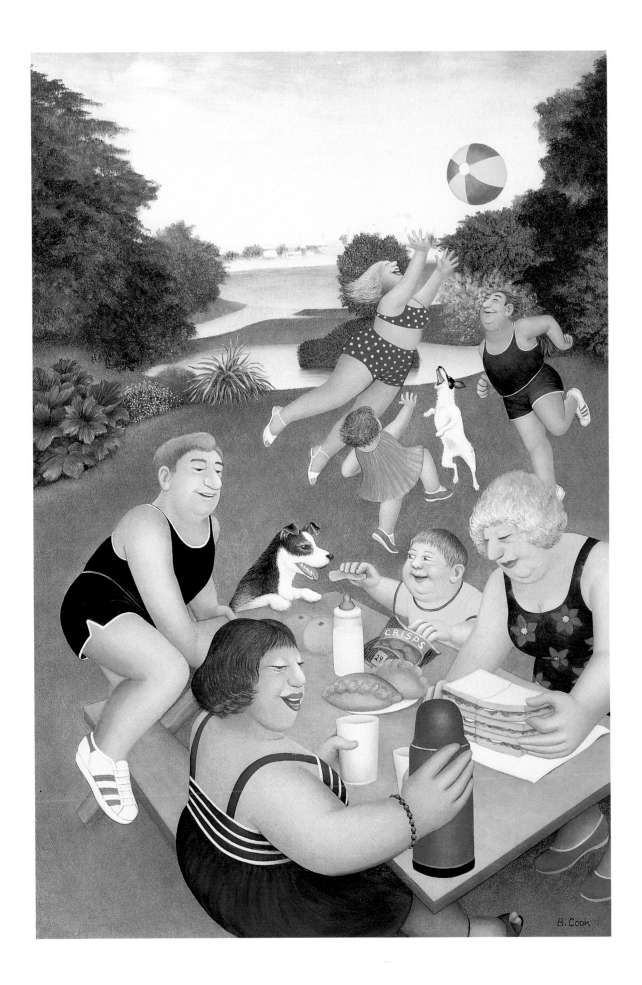

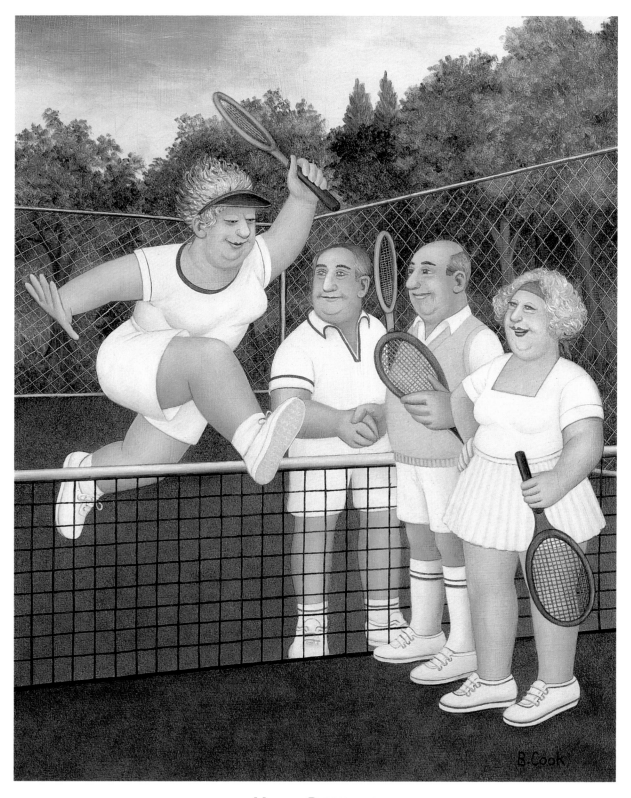

MIXED DOUBLES

The tennis season has started here, I see, and an exultant winner leaps the net at the end of her match. For some reason I thought that this was the usual way of celebrating a win, but I now recall that I have not actually seen it done. I rather like pictures of tennis players; their white clothes show up well against the green background and there's generally plenty of action. I did have a teeny problem with the rackets. Although I copied the details faithfully from a tennis catalogue, I suspect that they are rather on the small side.

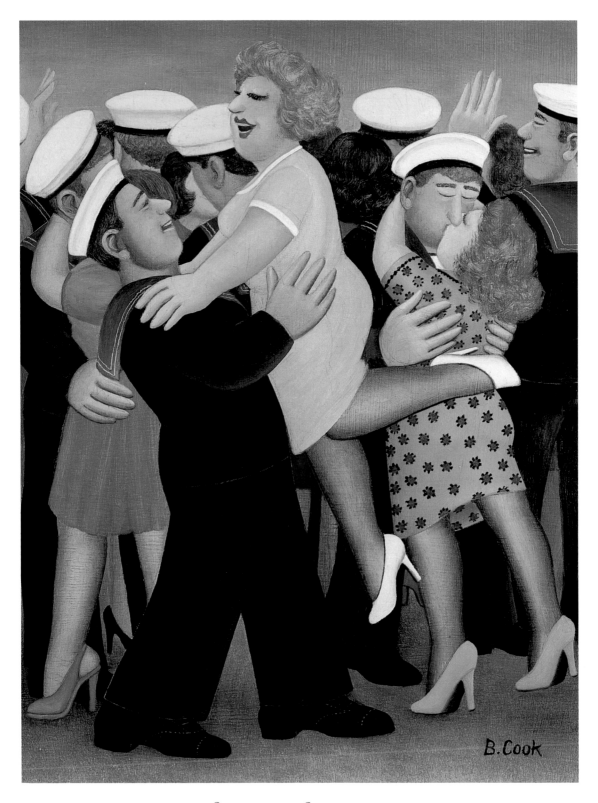

SAILORS & SWEETHEARTS

I like this kissing picture. I've seen the wives and girlfriends sadly waving the
sailors off on a tour of duty, and it must be wonderful greeting them home
again. It started with just the one sailor lifting his girlfriend into the air, but
when I saw I'd need to fill in a background I hastily decided to add a
few more bodies, which I'd much rather paint.

GOING SWIMMING

I saw this young family walking on the Hoe but I wanted a picture of the sea so that is where they are going now.

We don't have much sand in Plymouth but many little sun-bathing terraces placed among the rocks, and on these people spread their towels and lie in layers, sunning themselves. I always used to have an ice cream when I went down to the children's pool with my granddaughter Alexa. Now she is grown up with a family, and I can no longer stagger up all those steps.

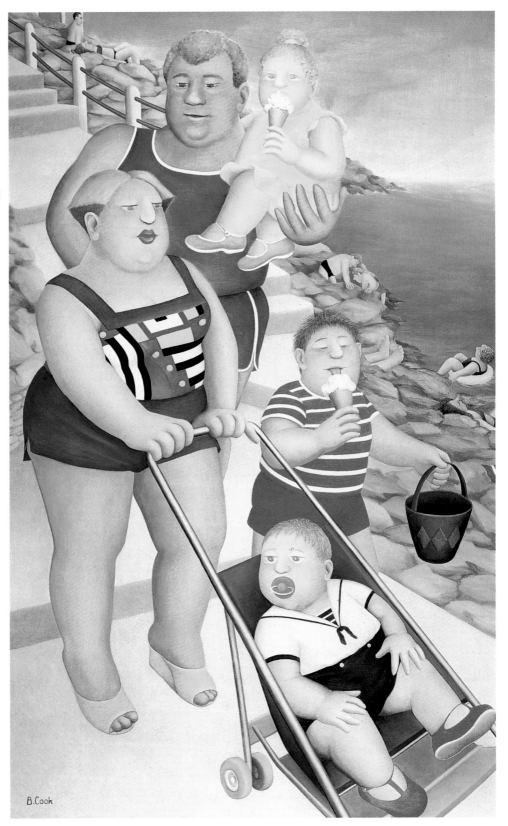

B.Cook

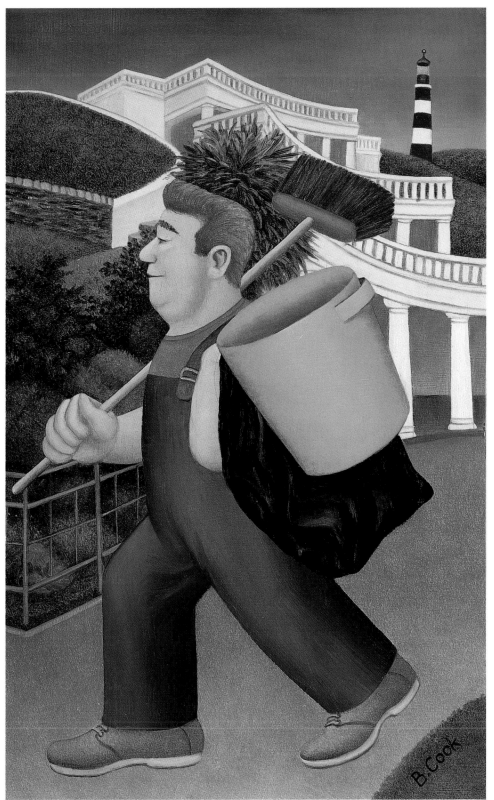

GARDENER ON THE HOE

Here is one of our gardeners: I saw him marching along with the bucket and black bag and I decided then and there to paint him. The gardeners wear smart green uniforms and do a very good job here and in our other parks. They also look after the flower beds we have all over the city. We sometimes invite them across to attend to our garden as well, but they don't take any notice. When I'm painting the Hoe I always like to include the lighthouse, and to do this I moved it away from its usual position to fit nicely into the corner.

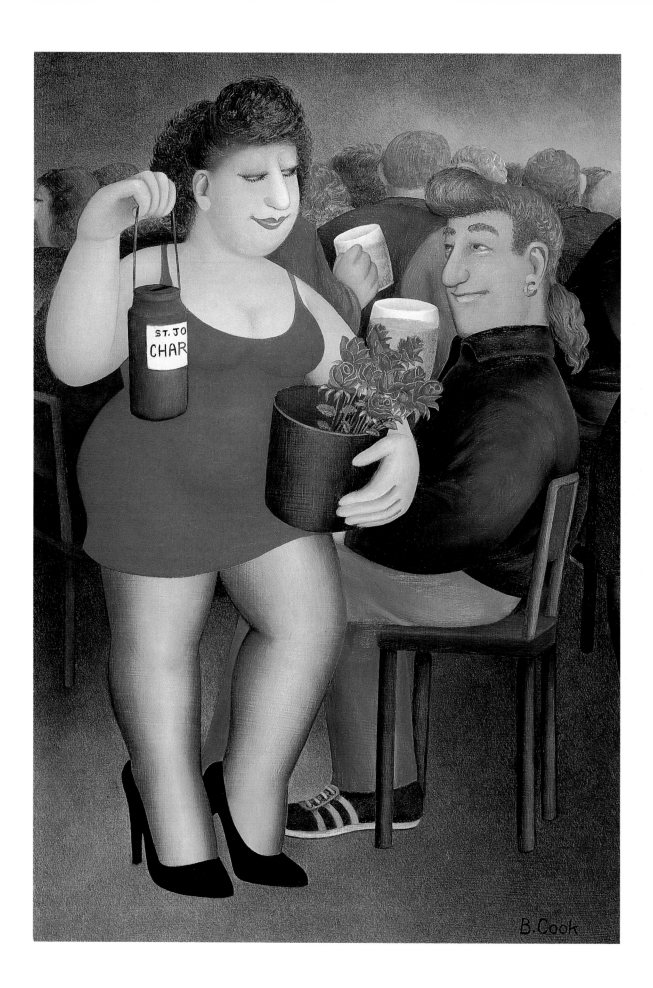

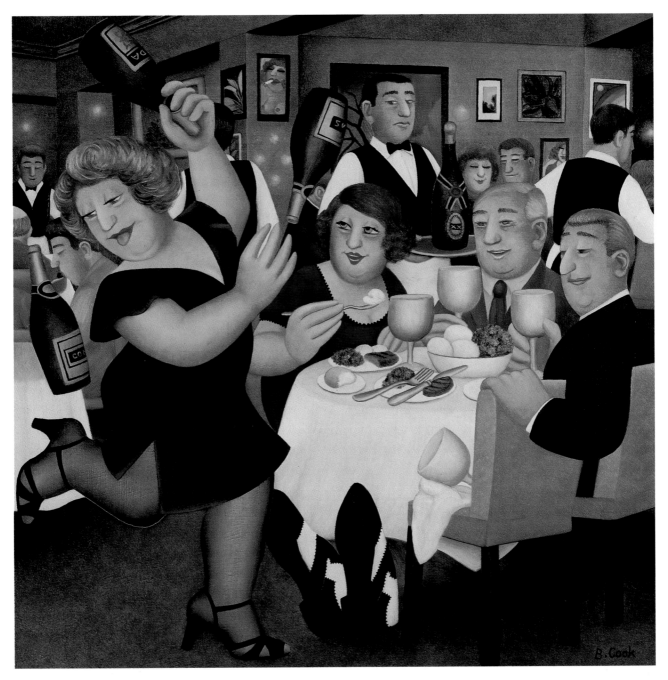

SWEET CHARITY *opposite*

This pretty girl in a tiny red dress used to appear in
our local pub every weekend. She was very attractive so
she probably did well in collecting for her charity. Here
she is tempting someone to buy a rose and, to be in
fashion, I've given him a big bushy ponytail. I wasn't
quite sure what to do with the front of his hair but
eventually arranged something bouffant. The roses I
painted from a gardening catalogue: they're quite
effective, aren't they?

DINING OUT

This picture was painted for the Portal Gallery's
Christmas show, on the theme of Eat, Drink and Be
Merry – which is exactly what is happening here. One
of the revellers has overdone it rather and is lying under
the table, but the others are still in full swing and
enjoying the impromptu juggling exhibition. I too
would enjoy seeing something like this but have not
been so fortunate. I have, however, seen a pair of two-
tone shoes emerging from beneath a table as the owner
snored away the evening. There's plenty of cabbage and
potato to dine on – two of my favourite foods.

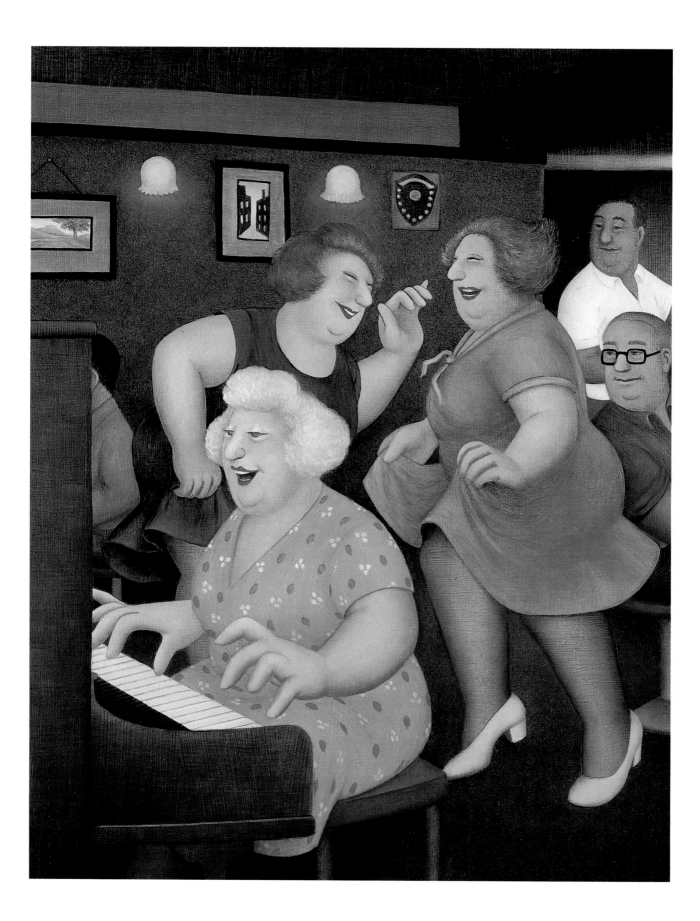

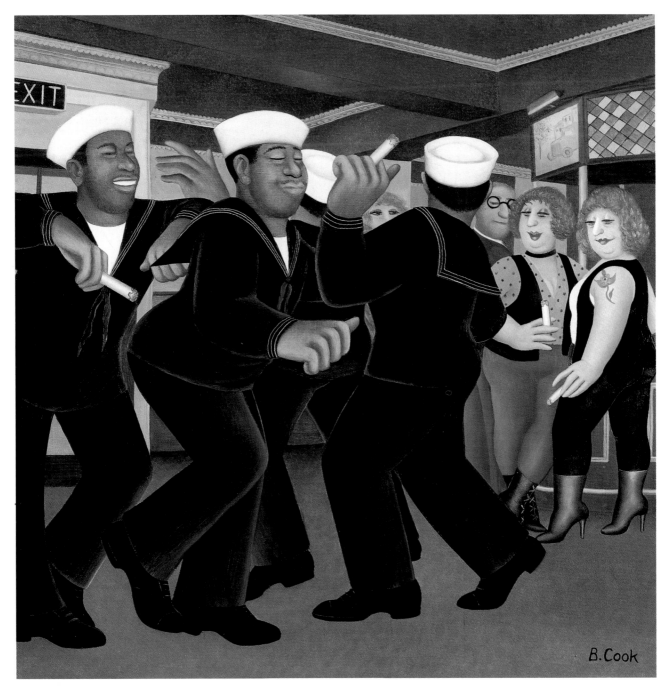

SONG & DANCE *opposite*

Here's another merry interlude, this time in a public house. I don't see people dancing in pubs so much these days, or playing pianos, but years ago we had plenty of episodes like this and it was mostly women who did the dancing. The one playing the piano is based on an ancient man I saw performing in a seaside pub, more or less toothless and happily singing along as he belted out the tunes. I thoroughly enjoyed his concert but decided to change him to a woman for the painting.

SAILORS DANCING

Another pub, with music from a juke box, and this time it is the sailors' turn for a dance. Not quite the hornpipe, but most enjoyable nevertheless. There was a buzz through Union Street – our nightclub area – last year when news came through that a large American ship would be here for a few days. This group was sitting in the booth next to ours, dressed in civilian clothes, but I dearly love uniforms (especially sailors'), so this is how they appear here. The girls look on admiringly but the sailors seemed to me to be much more interested in drinking, laughing and dancing.

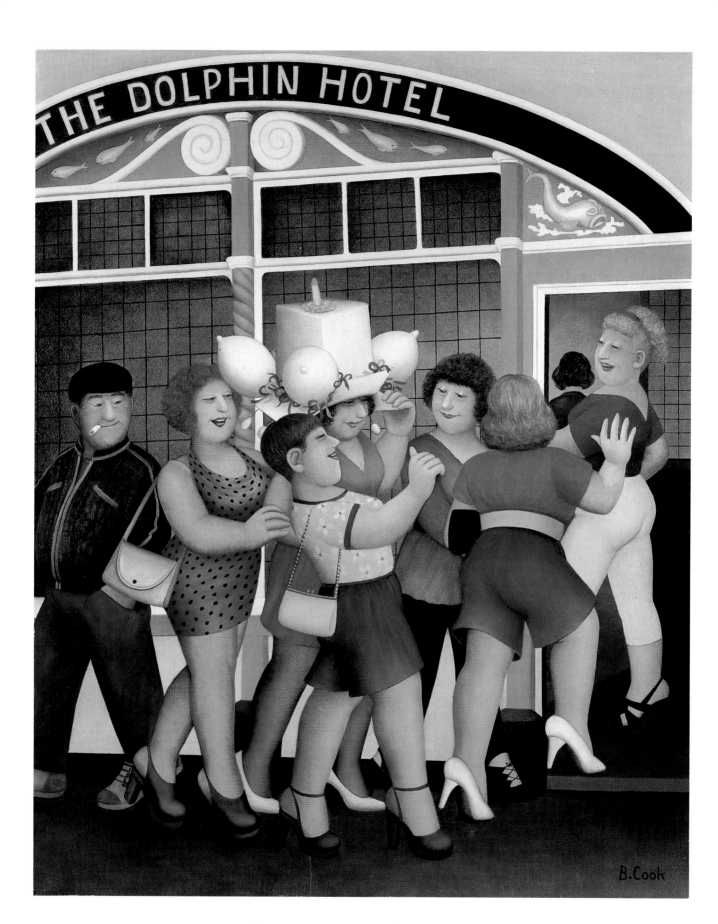

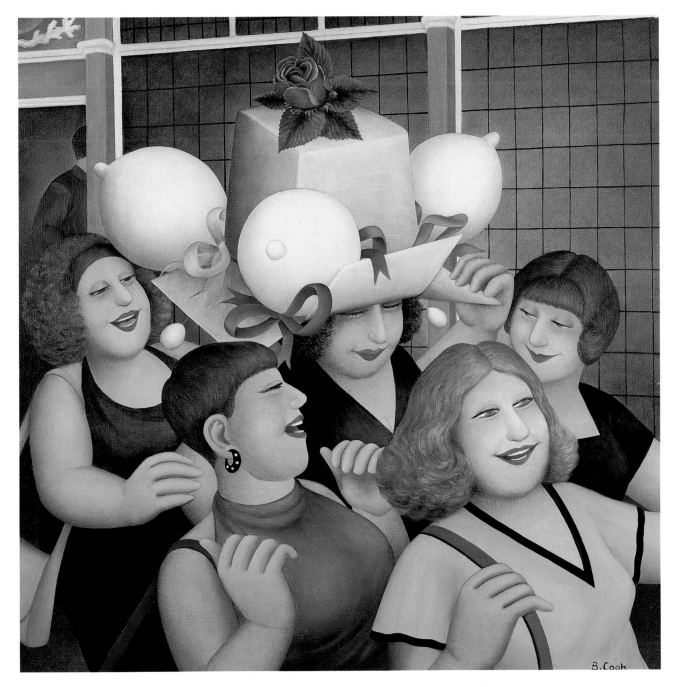

HEN PARTY *above and opposite*

This is something we see quite often, a bride-to-be being escorted from pub to pub by her friends, pausing for a drink in each. The friends make her a hat (in this case a large cardboard box covered in silver paper and saucy decorations), and there is much singing and hooting as they go through the streets. I am interested in these customs and learned that a bride getting married for the second time will also have a hat, but a much smaller one and more subdued. At the stag

parties the bridegroom gathers with his friends for hearty choruses of dirty songs, and occasionally this ends with the ripping off of the bridegroom's trousers.

After finishing the first painting I decided to do another with a much larger version of the hat, for by this time it had become an obsession. So here it is, with the girls slightly altered. I'm glad to say I have been able to leave this subject alone now.

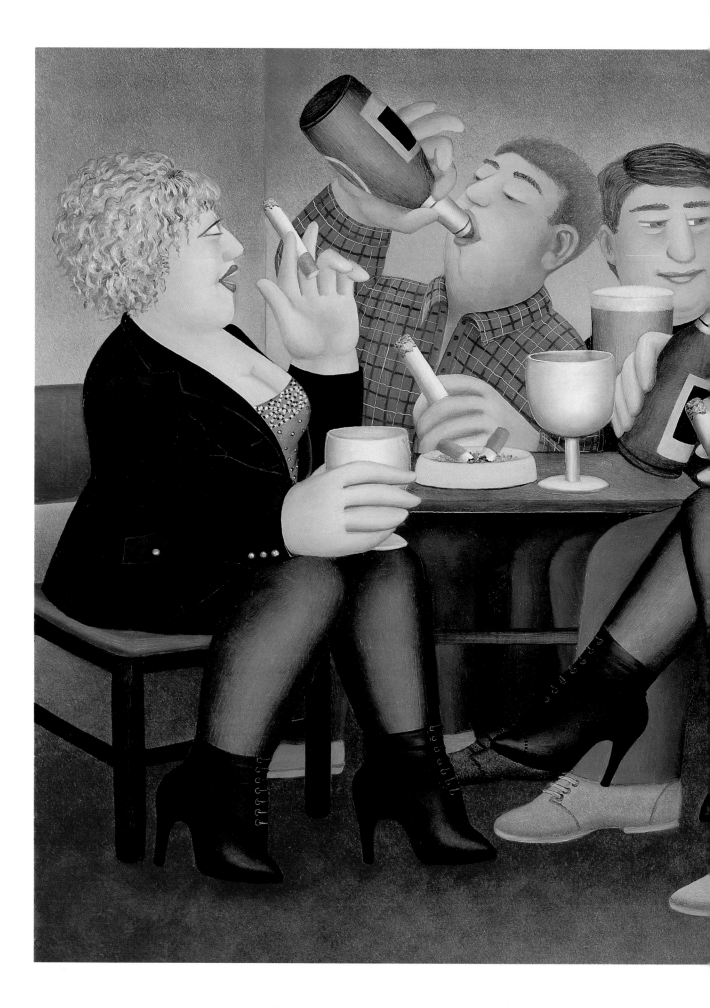

BOSOM PALS

I often see people drinking from bottles now, girls
as well as boys, although I have not yet mastered the
art myself. This was a group I noticed one evening
because the two girls were dressed in identical black
suits and bootees, the only difference being the
colour of their bodices, scarcely covering enormous
bosoms. They had come into the bar alone but it
was not long before they found seats, one on a
pair of knees, with these young fellows at a nearby
table. When I came to paint the scene I needed
some cigarette stubs for the ashtray and suddenly
remembered that I don't smoke any more (worst
luck). Friends kindly donated their dog-ends and
now I keep these to hand, ready for use when
required.

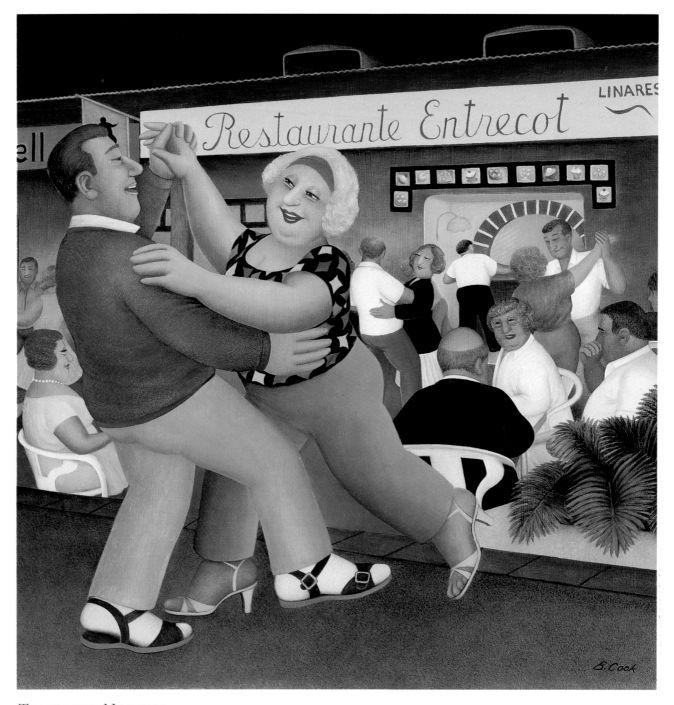

TENERIFE NIGHTS

We have been to Tenerife twice now, in the middle of
our rather dreary English winters. And what absolutely
lovely sunny weather they have there. These suntanned
bodies were having a good time in one of the many
little bars near the hotel. The bars are large, open patios
a few steps below pavement level and each has someone
singing and playing the organ, or has music from a
juke-box, so that people can have a drink and a dance.
Passers-by saunter along the pavement, enjoying the
music and activities. The couple here stopped for a little
dance before going on to whatever they had arranged
for the evening.

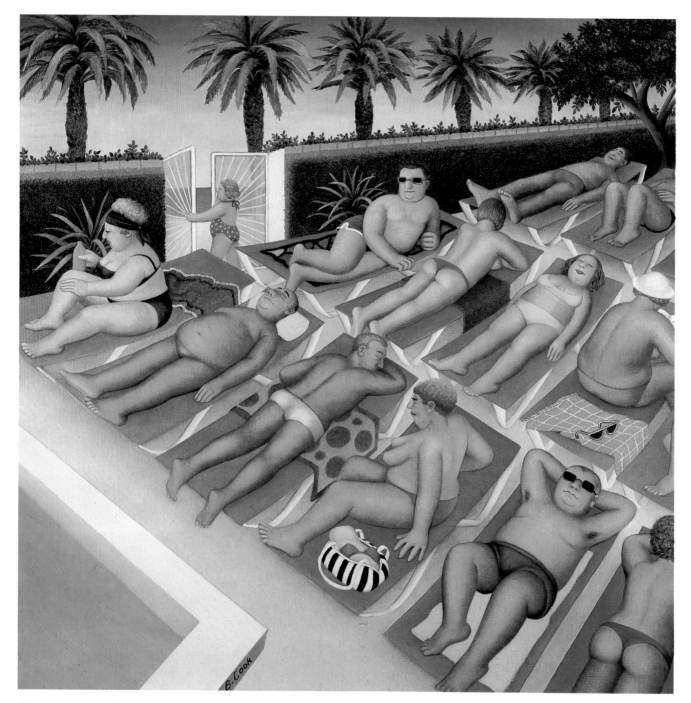

TENERIFE DAYS

During the day it was much too hot for me to stay in the sun, so I was amazed to find these people still lying on their sunbeds when we got back to the hotel in the late afternoons. The beds were booked with a towel first thing in the morning, and then the ritual of tanning took up the rest of the day. Each part of the body would be turned to the sun's rays at regular intervals, some going deep mahogany, some golden and others scarlet. To get these variations in the painting I spent about two days working on each figure.

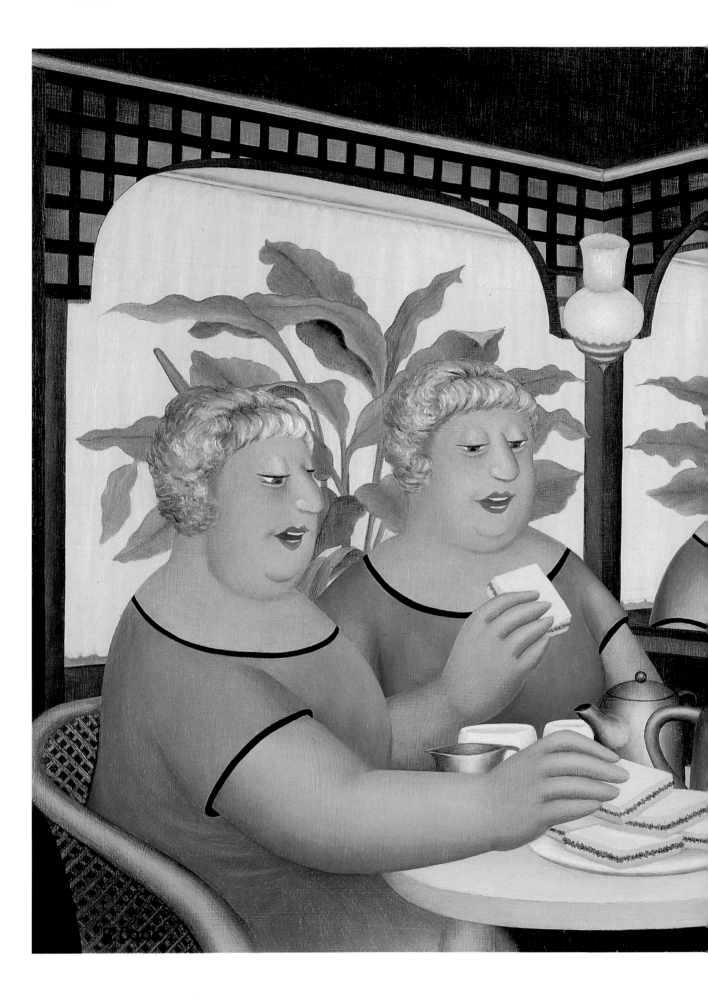

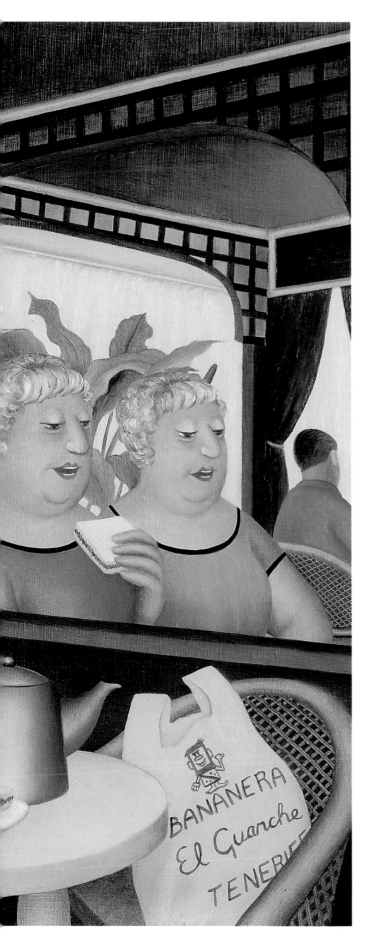

REFLECTIONS

This is a café at the top, rather more sedate end of Tenerife. Up here the scenery is greener and more lush, the climate cooler and much wetter. We had hired a car to travel around the island and stopped here for a drink. I noticed a pair of middle-aged twins having afternoon tea quietly together – better still, they were beside a large mirror. I have always liked twins, and here they were twice over – I could hardly wait to start the painting. Oh, what a task I had set myself – I not only had to paint two identical faces but two more in reverse! If I ever come across triplets by a mirror, I shall resolutely look away.

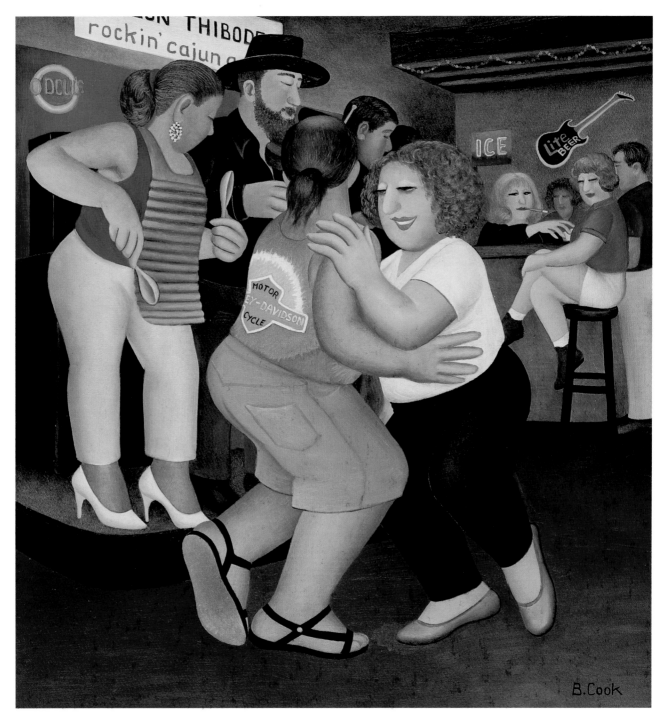

DOING THE CAJUN TWO-STEP

We were watching this couple in a bar in New Orleans late last year, performing expertly to the band which had attracted us inside. During an interval we asked the name of the dance and were told it was the Cajun Two-Step, which seemed an ideal title for a painting.

I like Cajun music very much – I'm particularly partial to the spoons – and another big attraction of this bar was the long happy-hour when two drinks could be had for the price of one. All this made a most satisfactory evening's entertainment.

THE LOBSTERS

Here is another scene from our visit to America, this time in the wonderful Oyster Bar in New York's Grand Central Station. This couple from Japan were sitting at the table next to ours. Despite their size – both were small and elegant – they had enormous appetites and these lobsters were just one part of their dinner. I myself had merely a monster bowl of clam chowder, which was decidedly filling, so I watched the various courses arrive at their table with great interest. When I came to paint the picture I used one lobster as a model, turning him round to get the two views. Then we ate him. He was *delicious*.

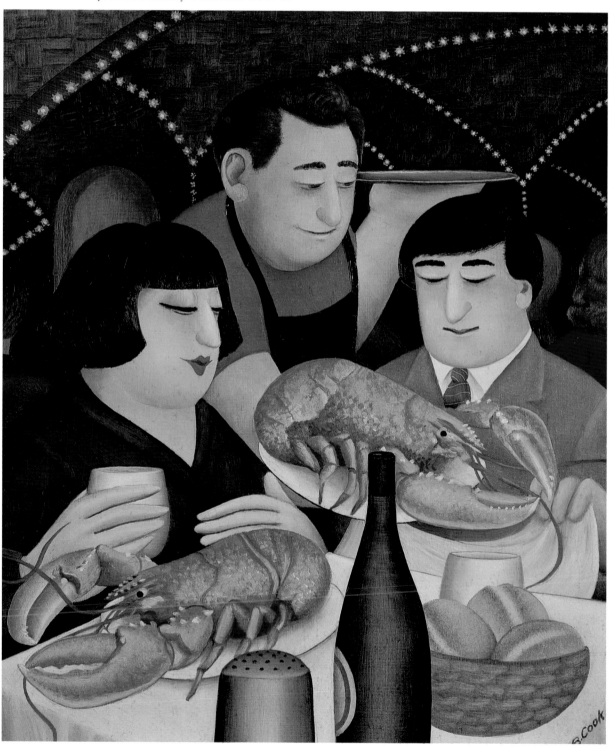

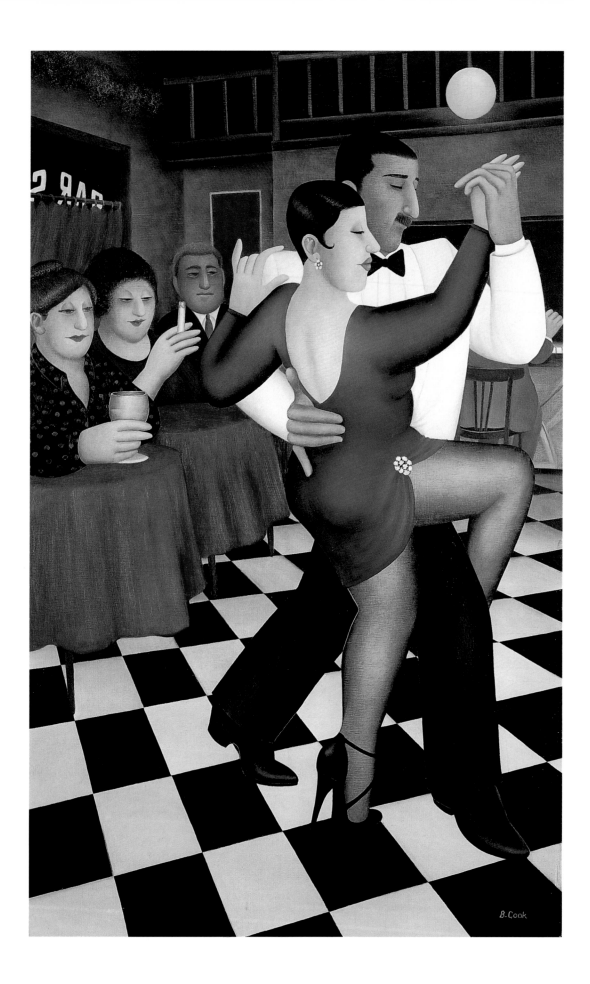

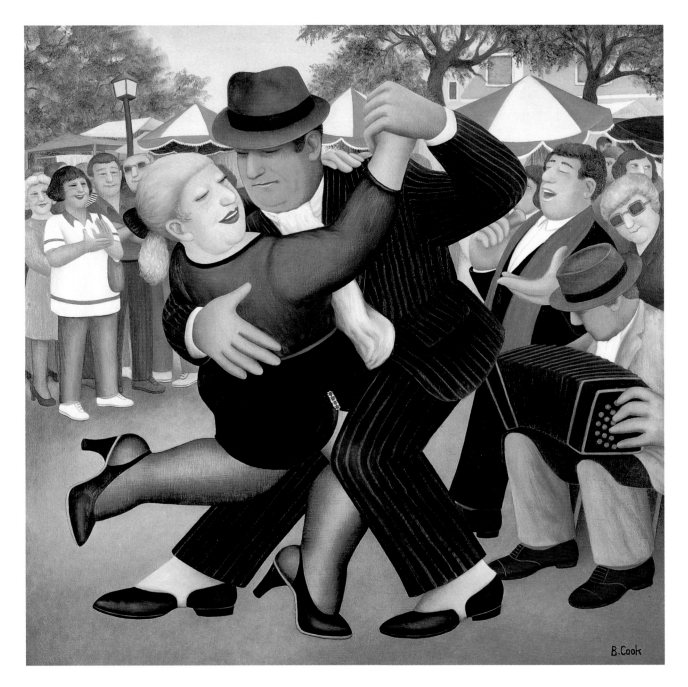

B. Cook

TANGO IN BAR SUR *opposite*

Two years ago we decided to go to Buenos Aires especially to see the tango, the most exciting and seductive of dances. As we were having a drink in a bar on the night of our arrival this couple got up from seats at the back, the piano and accordion players took their positions, and they all gave an absolutely stunning display. For two weeks we spent every evening and sometimes afternoons as well watching and listening to the tango, which is not just dancing but songs and music as well. It is the dance, though, that excites me most of all.

TANGO IN SAN TELMO

Tango never stops in Buenos Aires and whilst we were examining the stalls at the outdoor antiques market held on Sundays in San Telmo Square a little band assembled. It consisted of an accordion player and a guitarist, joined by a singer with his microphone and these two dancers. This drew a large standing audience as well as those seated at the café tables enjoying a drink in the sunshine. Here the man wears the uniform most often worn for this dance, a chalk-stripe suit with a white silk scarf, and a felt trilby on swept-back hair, glistening with grease like patent leather.

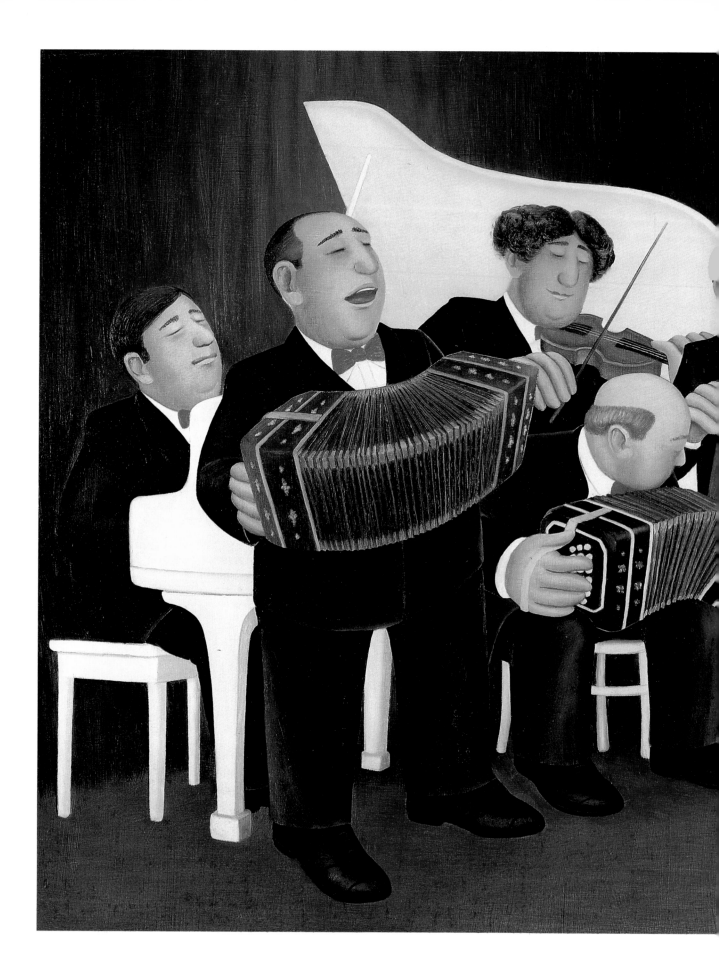

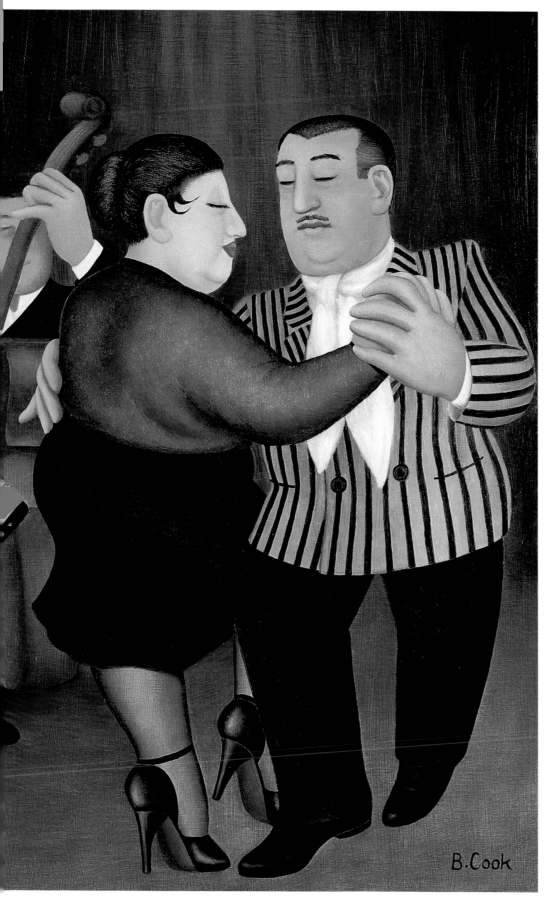

TANGO BAND

Tango bands can be very exciting, and I was so carried away with an afternoon show in the Municipal Theatre that I eagerly purchased one of the tapes on sale in the foyer as we left. This I did by sign-language – the audience and staff were entirely local and Spanish-speaking – which was a mistake. The tape turned out not to be the exciting rhythm of musicians at the peak of their performance, but a girl's heart-rending songs about Buenos Aires. Both the music and dance are treated very seriously indeed, as you can see from the faces in the picture.

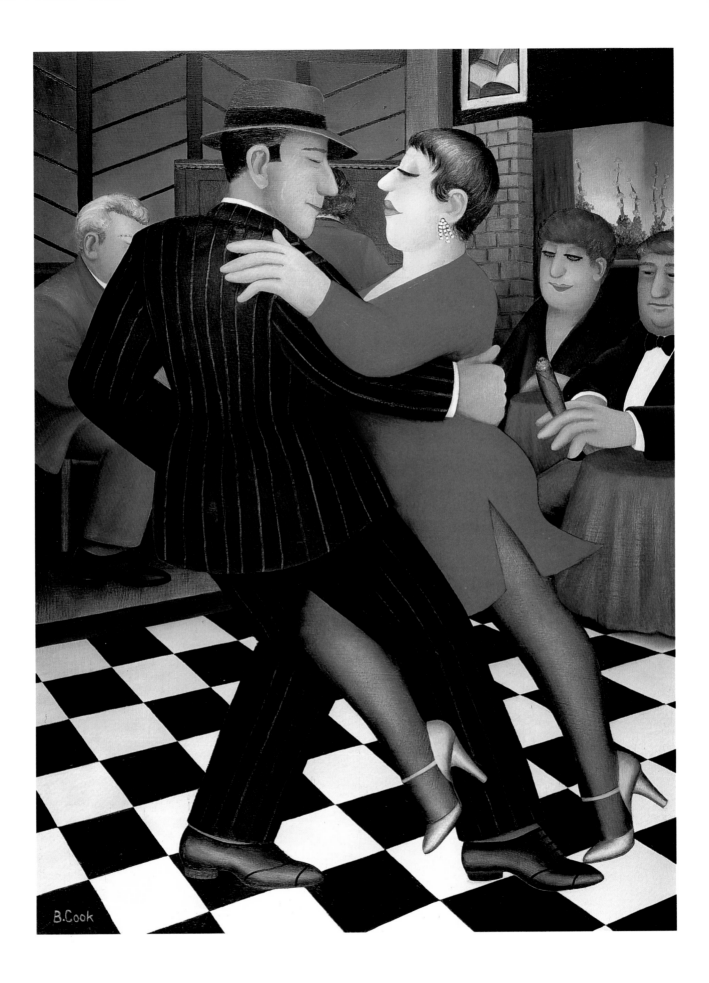

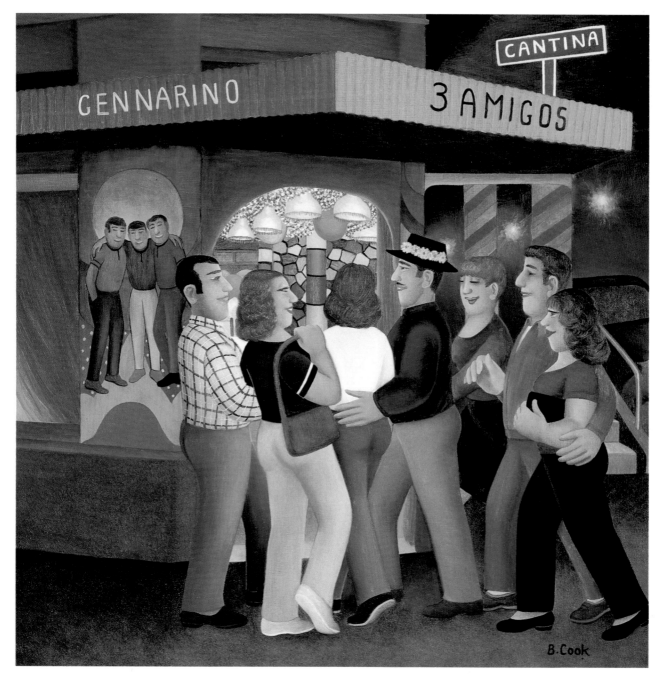

TANGO BAR *opposite*

Black and white floor tiles are popular in the bars here, and this is a little one we were taken to by a guide. It was empty, but a man magically appeared with an accordion while the manager busily poured us drinks. He then took up a microphone and sang a few songs from a book, finishing off by dancing with a little old lady who had arrived in the doorway. All this frenzied activity a few feet away from us had made me nervous, but just as I started to shake with laughter many more customers arrived, including these two dancers, and everything settled down.

3 AMIGOS CANTINA

We left the tango bar and Aldo the guide took us to a district called La Boca, which is down by the docks and considered rather dangerous after dark. Around there are the cantinas, song and dance halls for young and old, full of bright lights and loud music. There they eat and dance, have parties and – as on the night we were there – celebrate weddings. In the picture a wedding party is just going into the cantina, and the bridegroom is wearing the customary big hat. The outside of the building was actually much shabbier than I have shown, with lots of peeling paint on corrugated iron, but the inside was a riot of balloons, festoons, tinsel and lights. The people were very friendly and pleased that we enjoyed it all.

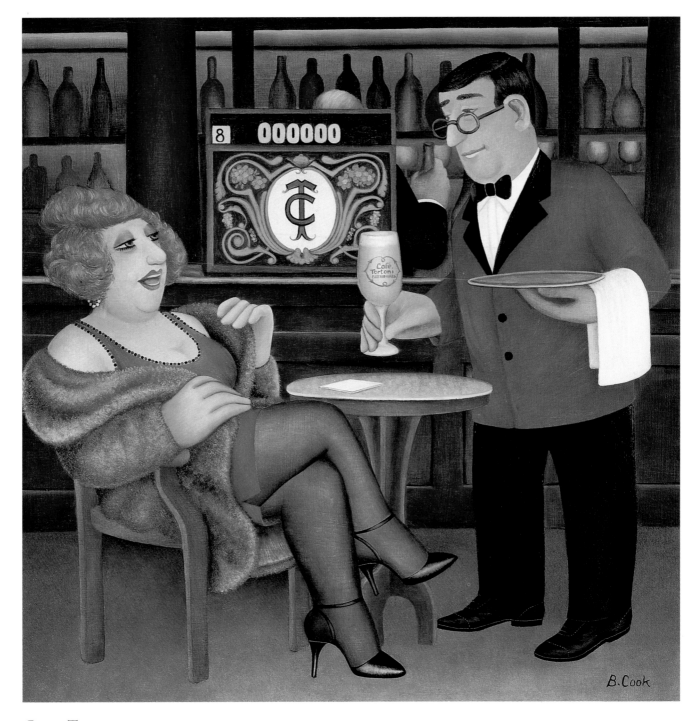

CAFE TORTINI

This is a very old café and the customers were generally middle-aged couples and families, but on one of our visits this lady wearing a tiny green dress under a fur coat was having a laugh with the waiters. She is in front of a handsome cash till, decorated with a style of popular art we saw on many things all over Buenos Aires, and the reason I painted this picture. The waiter is holding the glass we later purchased from the café as a keepsake. I can strongly recommend the delicious hot chocolate served here and in all the other cafés.

PAVEMENT IN BUENOS AIRES

A lot of the older ladies I saw shopping were very elegant, beautifully dressed and coiffeured. They often went about in pairs, sometimes threes, with arms linked, which is when I began to notice them. And perhaps the pavement you see here is the reason they are linked together – for support and not just friendship.

Many of the pavements we had to use were in this state, often with a variety of pipes emerging from the hole, and sometimes workmen too. Occasionally an old carpet would be thrown over the rubble, making it easier to climb. I watched these two men, busy with their hole, from a café on the opposite side of the street.

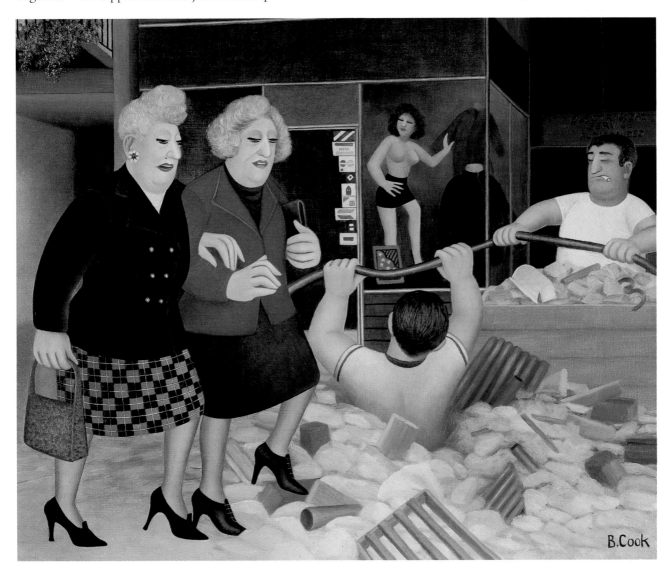

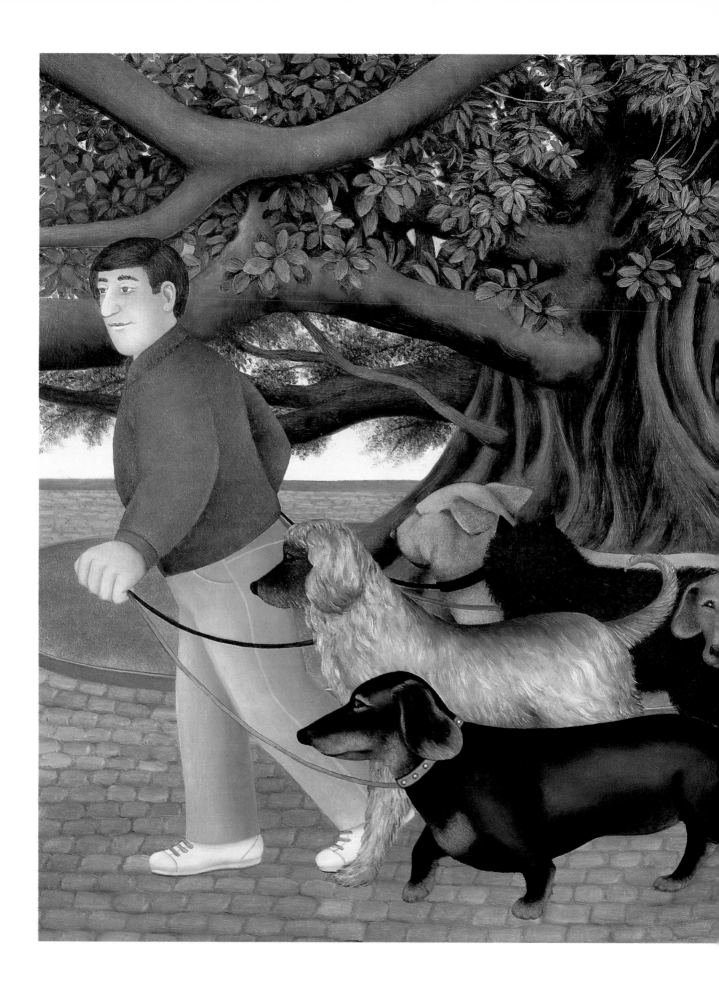

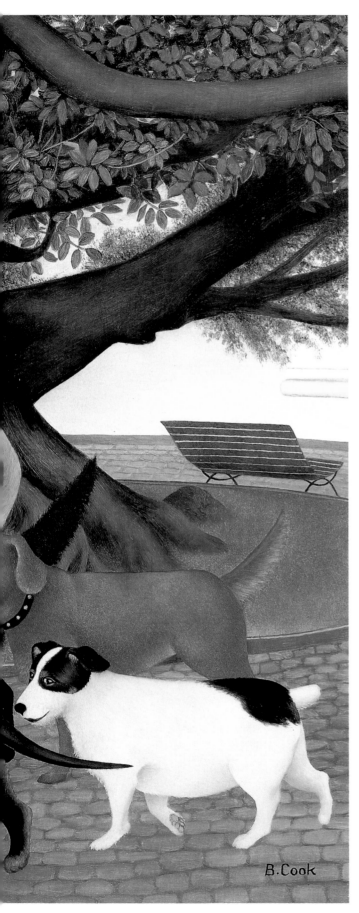

WALKIES IN BUENOS AIRES

Here is a bunch of more nimble feet, with no worries about tripping up, just eagerness to get to the park. The accommodation in the city is mostly in the form of apartments and as the dogs (and there are many) need exercising, the dog-walkers collect them in groups at regular intervals. They seem to be very well behaved. Here they are passing the oldest tree in Buenos Aires – so I was told. It is a magnificent and enormous tree situated in a part called La Recoleta, just outside the cemetery. I was fascinated by the tombs and mausoleums in there, for many of them are by famous artists, and it is all very well kept and cared for.

B.Cook

I especially like a city beside a river, or the sea. It didn't take us long to find the Clyde and when I saw a little dog running along beside it I wished ours was with us to do the same. The red bus on the bridge, with Dunkin' Donuts on the side, against a dark grey sky, was the start of this painting. The girl's outfit I had seen at the railway station earlier and liked it so much I used it here.

ACCORDION PLAYER

The next three pictures were painted after a visit to Glasgow, such a lively and go-ahead city. I quite thought I'd be surrounded by bonny Scotsmen dressed in kilts, which was the case when I'd been there in my youth, many years ago. Now they have made way for everyday wear, although a taxi-driver told me he had worn one for his wedding. So I was more than grateful to find this man wearing at least a plaid bonnet as he stood in a doorway to play his accordion. I've tried to make it as large and Scottish as possible.

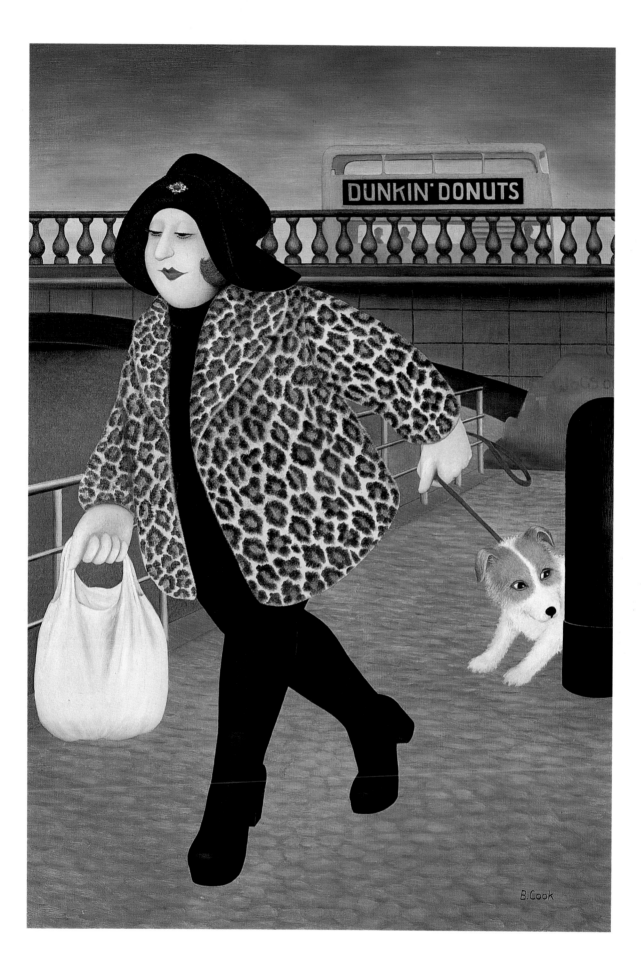

B.Cook

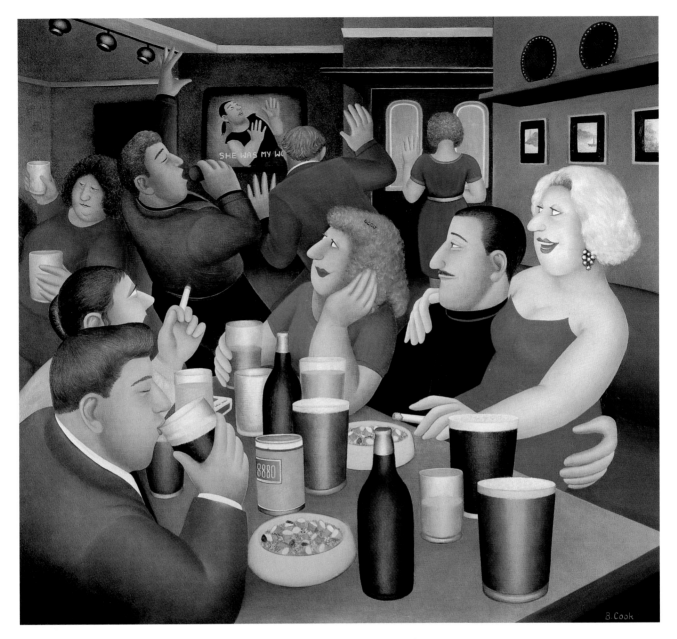

KARAOKE

We were taken to this pub by friends and I thoroughly enjoyed my first experience of karaoke in action. We went upstairs to a large room with a bar at one end and the karaoke machine at the other, with chairs and tables in long lines down the centre. Leaflets were distributed throughout, listing all the available songs, and we had to tick which ones we'd like to perform. I say we, but a million pounds would not have persuaded me to get up and take the microphone. Others felt differently; there was an eager queue to take the stage and I was surprised to find how very good most of them were at singing. I don't know whether this is peculiar to Glasgow or if I'd find such good voices in other pubs, for I've never seen it again.

RAB C. NESBITT *opposite*

Now here's a Scotsman I would like to have seen on the Glasgow streets. He is one of my favourite TV characters and he and his companions have kept me amused week in and week out. I just wish I could understand more of what he says – I don't like missing any of it. As he is so talkative and opinionated I thought he might have some political advice that could be useful to a prime minister, so here he is going into No. 10 Downing Street.

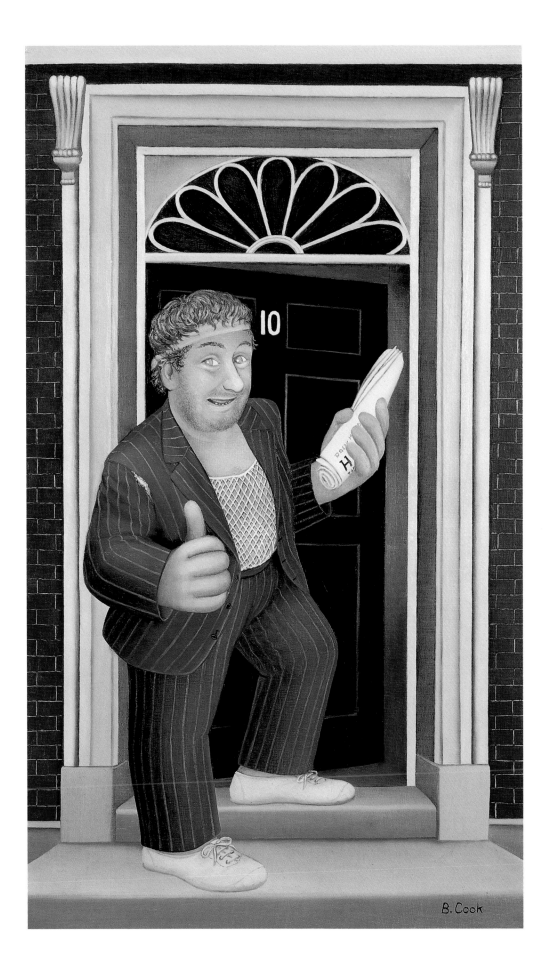

B. Cook

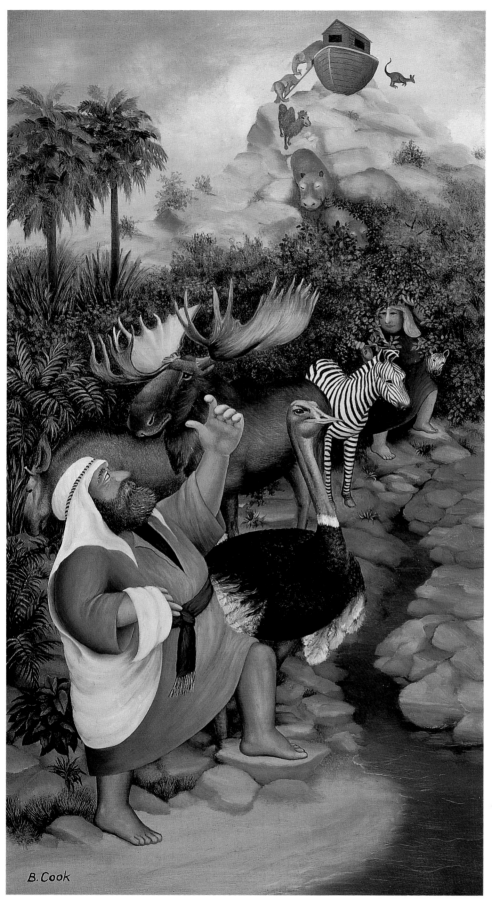

B. Cook

NOAH'S ARK

One year the Portal Gallery asked for a Noah's Ark picture for their Christmas show. I'm not very well up on tales from the Bible so they told me the story and when I found that animals, which I like painting, came down from the top of a mountain, I became enthusiastic, for it seemed such a good way to display them. How easy it all sounded, and how difficult it turned out to be, with absolutely no co-operation from Noah's wife. She is meant to be emerging gracefully from a leafy glade but looks more as though she's wrestling with the undergrowth.

A FINE FIGURE
opposite

Another year the theme was Proverbs, and I chose to do 'No Man is a Hero to his Valet'. To illustrate this I decided to put the gentleman into a corset, which I had to imagine, for I am relieved to tell you that no man I know wears one. I had the same problem with the sock-suspenders but after I had completed this painting a fan kindly sent me a pair, in case I ever needed to paint them again. I think I have made quite a good job of his combinations but have not been nearly so successful with his feet. They are quite worrying, aren't they?

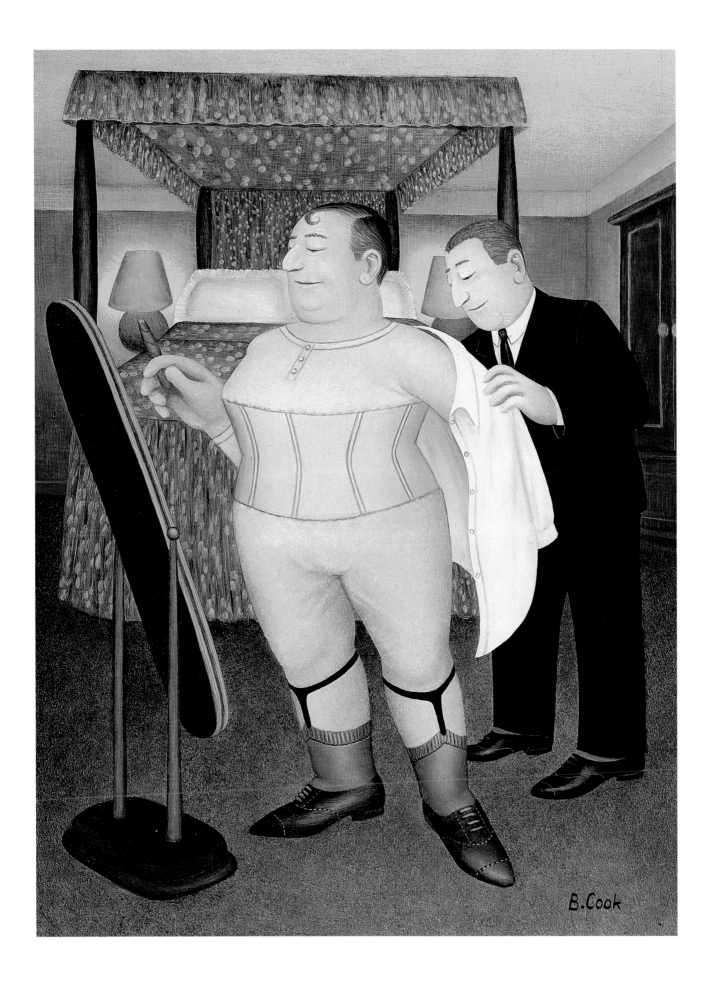

B.Cook

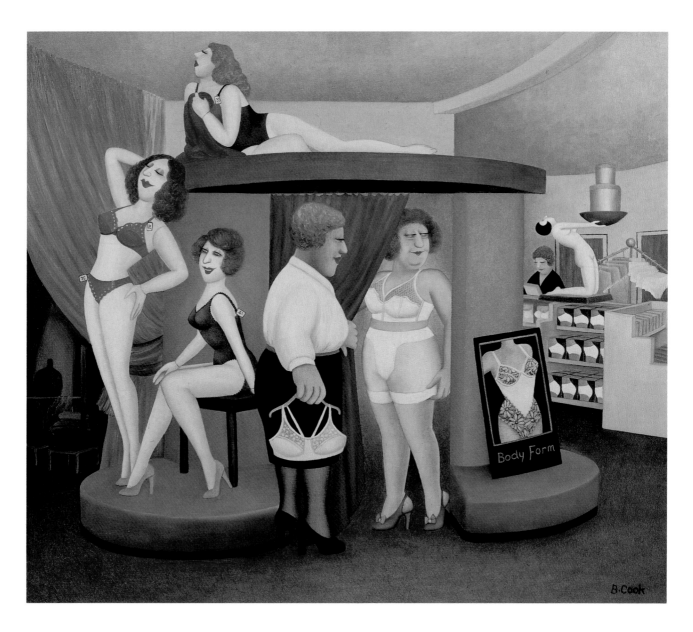

UNDERWEAR

The lady in the dressing-room is wearing a bargain I found in the sales, when I was in the corsetry department of one of our large stores examining the latest aids to obtaining a more svelte figure. This little purchase I tried on at home, causing such mirth that after I'd used it for the painting it was put to rest at the bottom of a drawer, never to see daylight again. The customer here looks quite pleased with the effect, though: I think she'll buy it.

PRIVATE EYE COVER *opposite*

I was pleased to be asked to do this cover for *Private Eye*, since I have enjoyed reading the magazine for many years. Most of all I like the cartoons, and one, of a chef mooning to a couple who dared to complain about the food, kept me laughing for about three days. It might be rather alarming for people to see an old lady like me permanently grinning and cackling to herself in the shops, but I expect at my age it is put down to senility. As you can see, this picture was painted some years ago, when these people were in the public eye, and for their faces I collected drawings and photographs from the newspapers. They are getting ready for a pantomime.

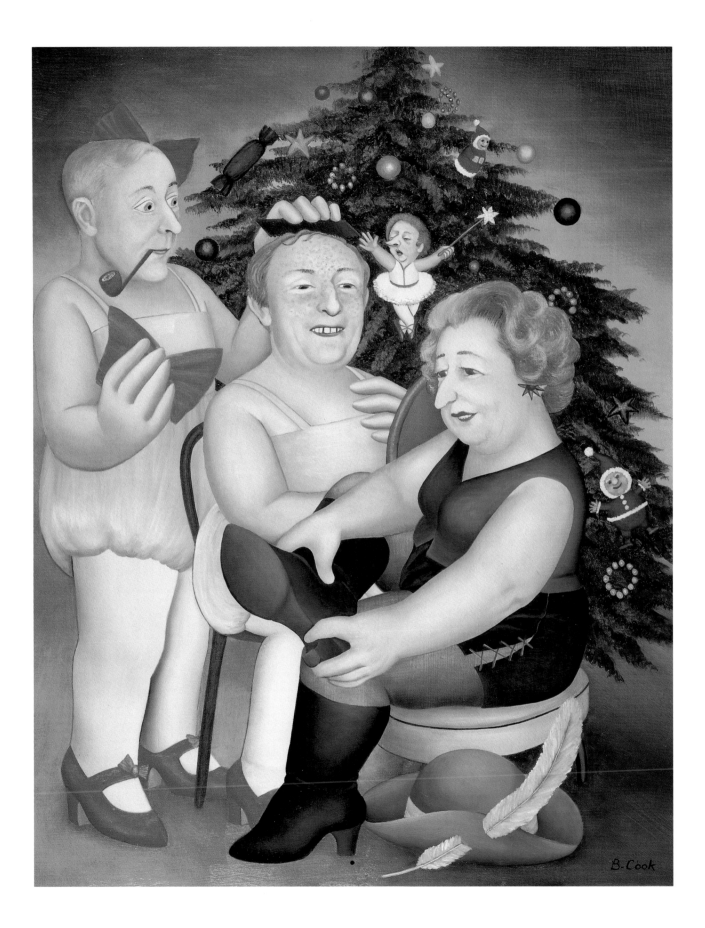

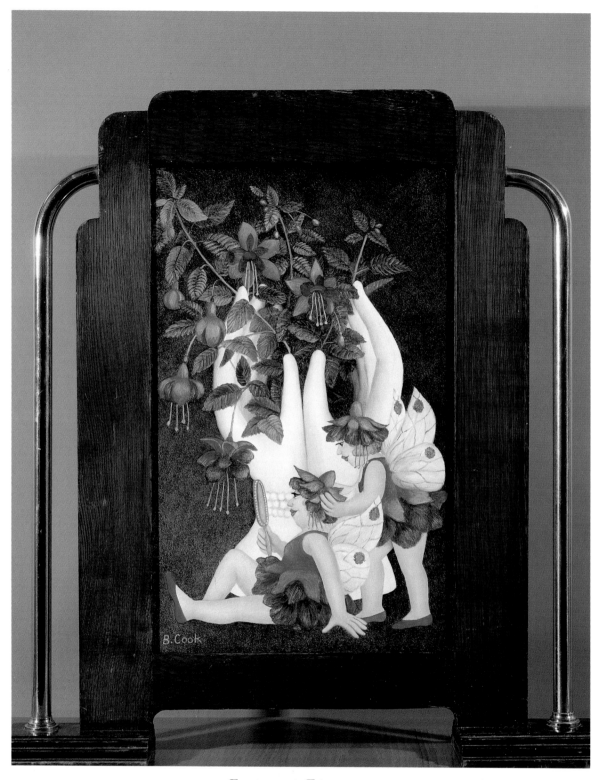

FUCHSIA FAIRIES

My son found this handsome fire screen at a boot sale, and knew I'd like it. I decided it was an ideal size for a fairy picture for my granddaughter Sophie, and as she is very fond of the pair-of-hands vase we'd bought from a market stall I used it to hold the fuchsias from the garden. I don't often paint flowers – it's mostly great big green leaves that I like – but these aren't bad, are they?

FAIRIES & PIXIES

And here is a fairy picture with the big green leaves and water lilies from our pond.
I blame Mabel Lucie Atwell for these paintings – her desk has been in our house
for some years now and it must be sending out vibrations.

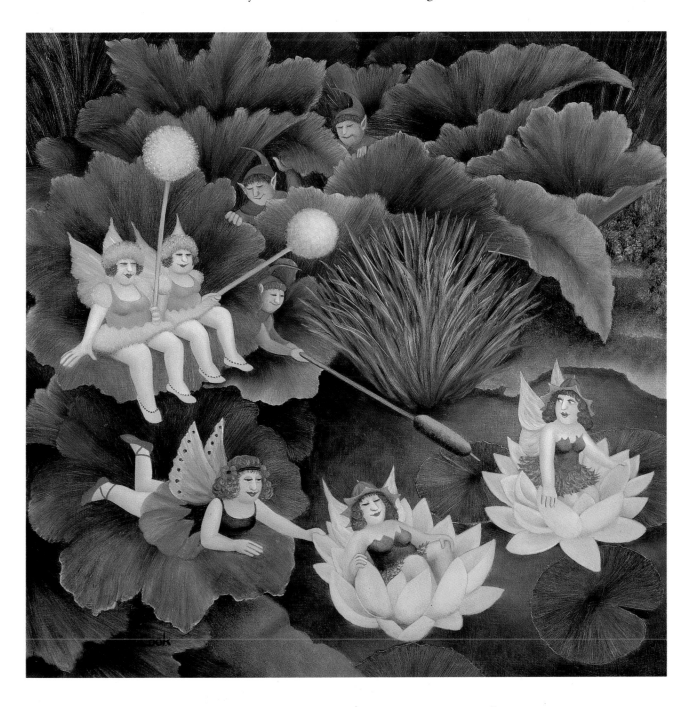

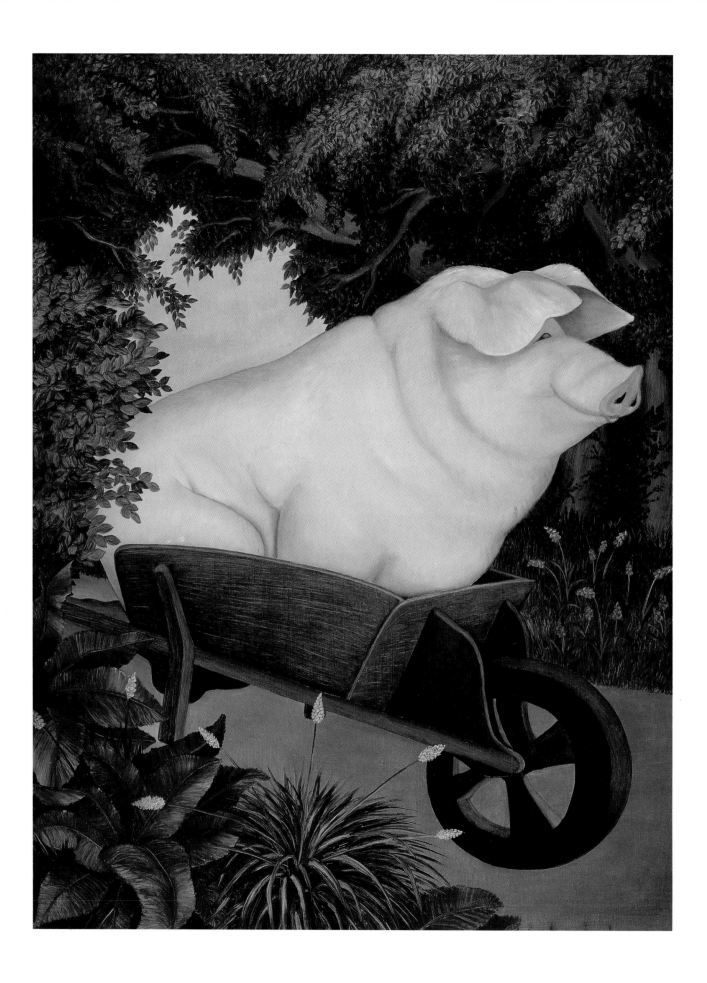

TAURUS

The signs of the zodiac were the theme for another Christmas show
and I chose John's, which is Taurus. He is rather handsome, isn't he,
against a celestial background?

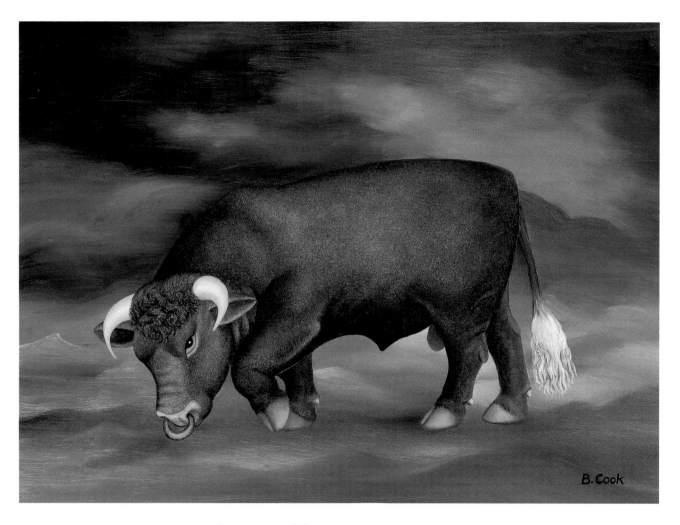

PIG IN A WHEELBARROW *opposite*

This pig was painted for a Portal Gallery exhibition, held some years ago. Even further
years ago we lived in the country and kept two pigs ourselves – Robert and Gutsy. We
both became devoted to these pigs and then the dreadful day came when we had to send
them off to market, and we knew we'd not be keeping pigs again.

VIRGO

This is my birth sign and when I needed something
suitable for her to ride I chose a zebra, the animal
who wears my favourite colour combination – black
and white stripes.

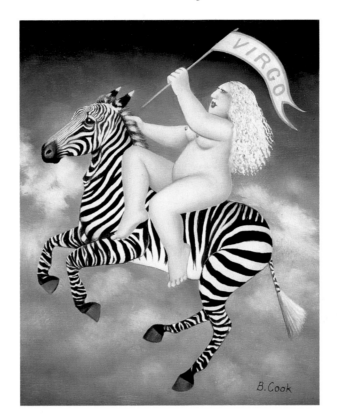

Beryl Cook's paintings are available from
Portal Gallery Ltd, London

Limited edition prints are available from
The Alexander Gallery, Bristol

Greetings cards and calendars are published by
Gallery Five Ltd, London

Original serigraphs and lithographs are published by
Flanagan Graphics Inc., Haverford, PA, USA